LOST YORK
IN COLOUR

— IAN D. ROTHERHAM —

I thank the series editors and the team at Amberley for their help, support, and encouragement.

First published 2016

Amberley Publishing
The Hill, Stroud, Gloucestershire, GL5 4EP
www.amberley-books.com

Copyright © Ian D. Rotherham, 2016

The right of Ian D. Rotherham to be identified as the Author of this work has been asserted in accordance with the Copyrights, Designs and Patents Act 1988.

ISBN 978 1 4456 5351 8 (print)
ISBN 978 1 4456 5352 5 (ebook)

All rights reserved. No part of this book may be reprinted or reproduced or utilised in any form or by any electronic, mechanical or other means, now known or hereafter invented, including photocopying and recording, or in any information storage or retrieval system, without the permission in writing from the Publishers.

British Library Cataloguing in Publication Data.
A catalogue record for this book is available from the British Library.

Typesetting by Amberley Publishing.
Printed in Great Britain.

CONTENTS

	Introduction: York, One-Time Capital City	4
1	Old York from Medieval Town to Modern City	12
2	Industry, Commerce & Urban Settlement	33
3	The City of York as a Centre for Rich Farming Landscapes & for Local People	49
4	A Rich City of Influence in the North	55
5	Victorian Squalor & Pollution	65
6	Education, Health & the Arts	79
7	Modern York Emerges During the Twentieth Century – a City of Parks, Gardens, Galleries, Museums & Splendid Houses	90
8	Transport In, Around & Through York	102
9	Sports, Theatre, Cultural Activities & Tourism	117
	Bibliography & Suggested Reading	127
	About The Author	128

INTRODUCTION
YORK, ONE-TIME CAPITAL CITY

York is known throughout the world because of its historic association with famous moments in English history, from Roman stronghold, to Viking capital. It was also the home of major industries, with chocolates made in the city and other manufacturing industries notable in times past. Today the city is the vibrant county town of Yorkshire with two universities, excellent theatres and a modest professional football club. York also has international sporting repute with the city hosting the famous York races.

The lifeblood of this remarkable city is the River Ouse, which runs north to south through York and then across the south-eastern lowlands of the Vale of York before joining the River Derwent, then discharging to the great Humber Estuary and finally the North Sea. Along the watercourses south of York, there are ancient floodlands, meadows and pastures at sites like Wheldrake Ings, a major nature reserve managed by the Yorkshire Wildlife Trust and Natural England. Steeped in history, culture and remarkable heritage, York draws visitors from all over the world. Today a major tourism centre, the city has excellent shopping facilities, restaurants, hotels, museums and galleries and two major universities.

Thoroughly to master the story of the city of York is to know practically the whole of English history. Its importance from the earliest times has made York the centre of all the chief events that have taken place in the North of England; and right up to the time of the Civil War the great happenings of the country always affected York, and brought the northern capital into the vortex of affairs. And yet, despite the prominent part the city has played in ecclesiastical, military, and civil affairs through so many centuries of strife, it has contrived to retain a medieval character in many ways unequalled by any town in the kingdom. This is due, in a large measure, to the fortunate fact that York is well outside the area of coal and iron, and has never become a manufacturing centre, the few factories it now possesses being unable to rob the city of its romance and charm.

Gordon Home,
Yorkshire, 1908

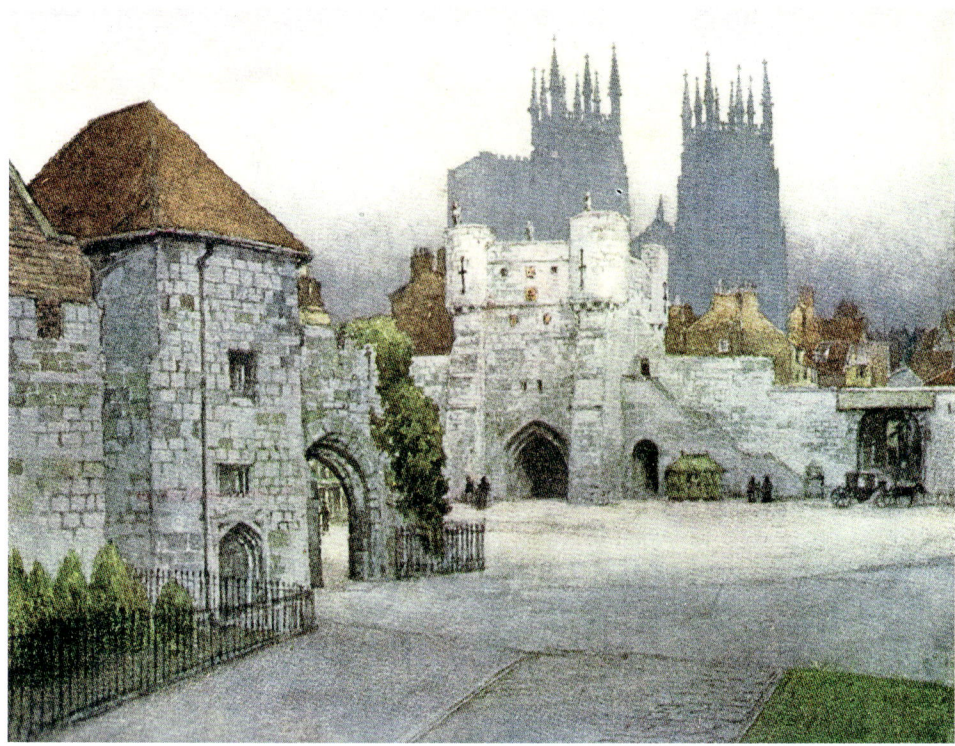

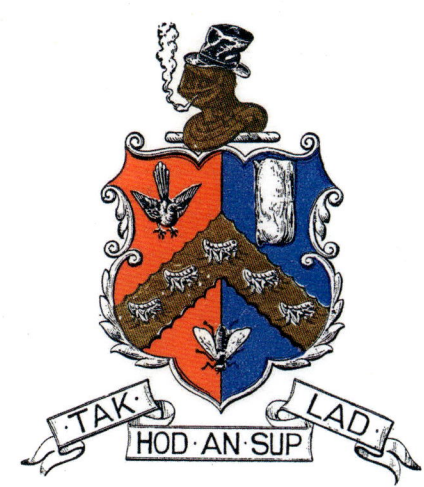

Above: Bootham Bar and the Minster in the early 1900s.

Right: A Yorkshire coat of arms.

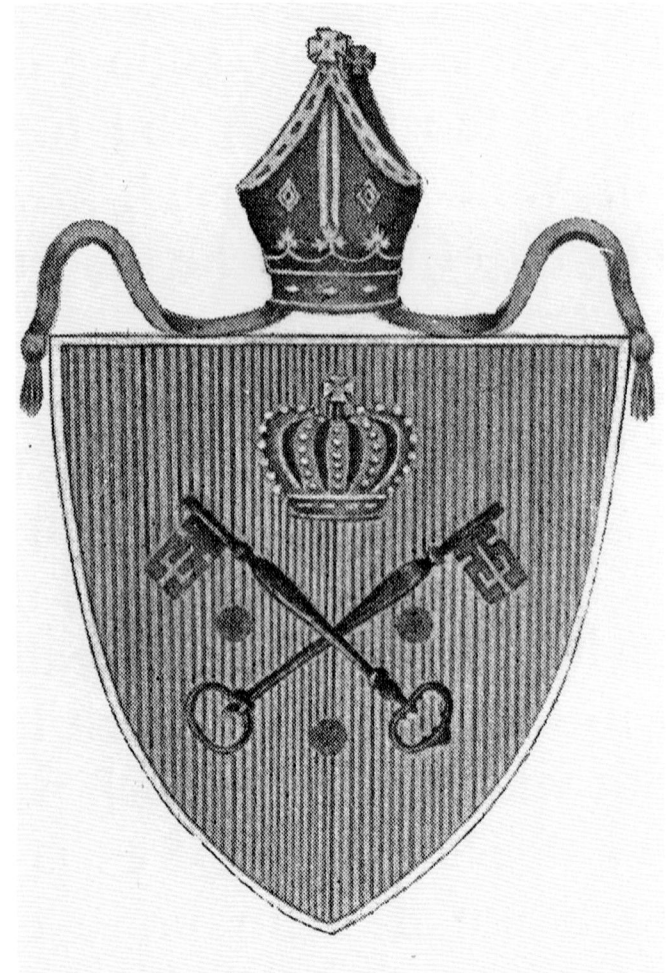

Above: City of York coat of arms.

Left: Coat of arms of the See of York.

LOST YORK IN COLOUR 7

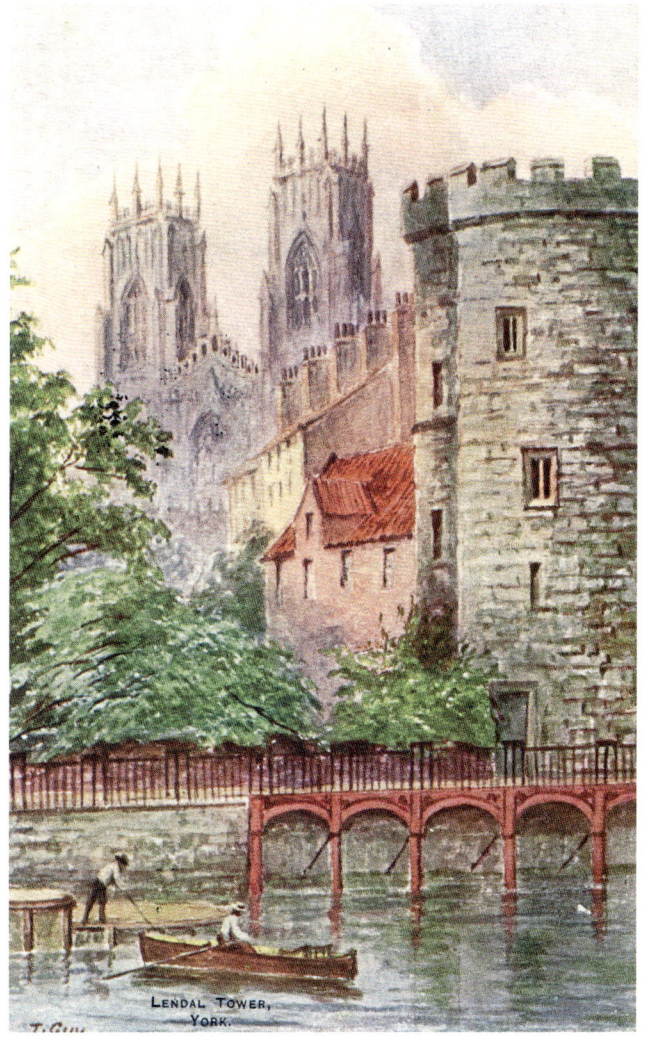

Above: Map of York in the early 1600s to show the compact nature of the medieval city.

Right: A lovely view of Lendal Tower and the Minster around 1908.

8 LOST YORK IN COLOUR

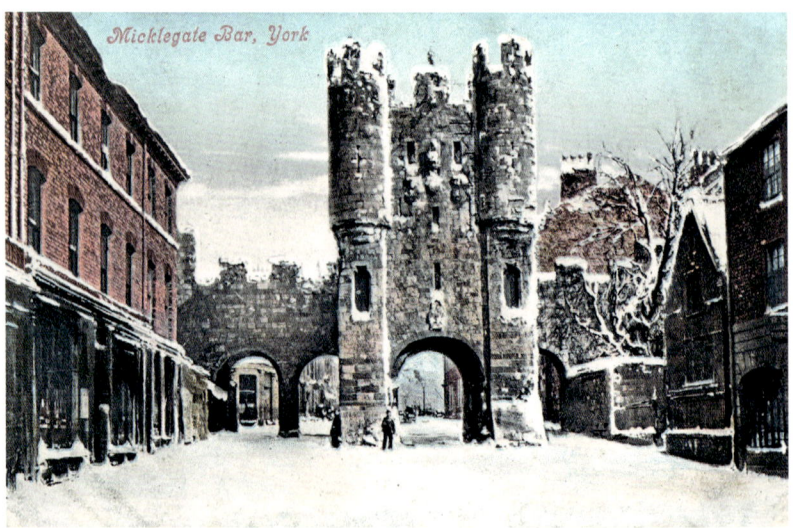

Above: A nice winter view of Micklegate Bar in around 1908.

Left: Micklegate Bar with pedestrians in the late 1800s.

LOST YORK IN COLOUR 9

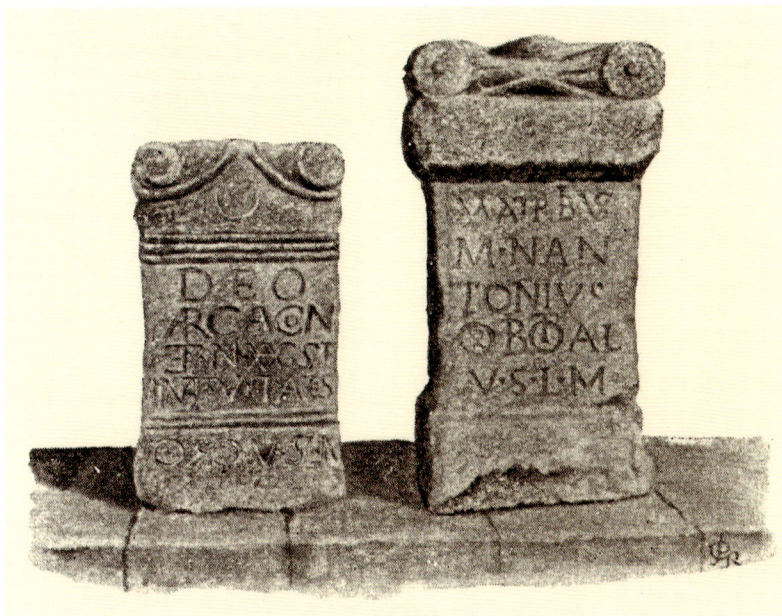

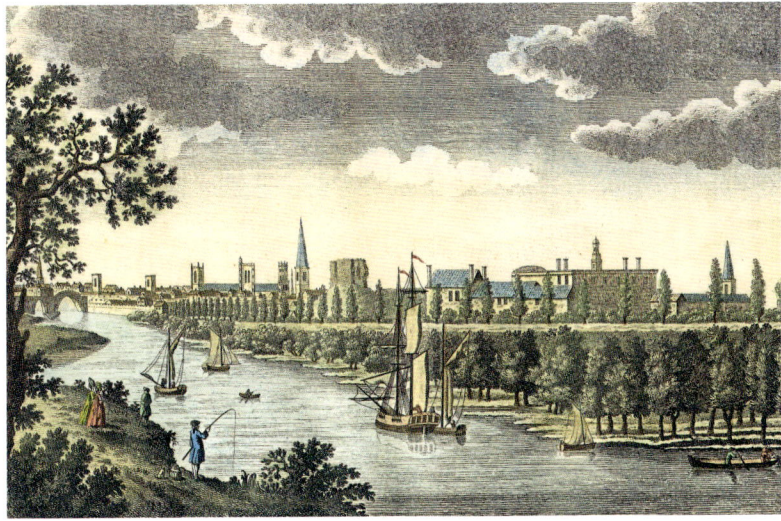

Above: Roman altars at York.

Above right: Roman keys at York.

Below right: View of the City of York from the River Ouse from the *Modern Universal British Traveller,* in the late 1700s.

York and its surroundings shown in the 1970s.

LOST YORK IN COLOUR 11

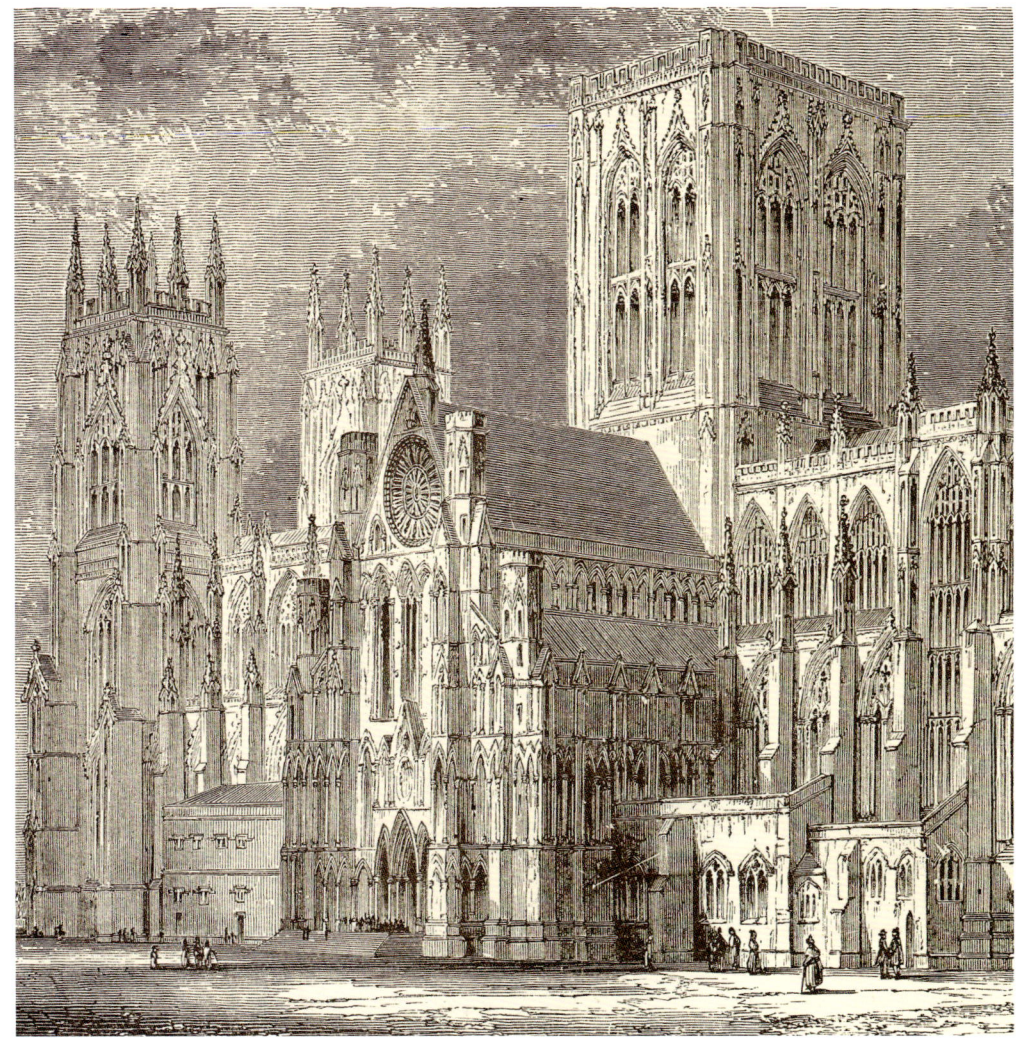

York Minster, 1800s.

OLD YORK FROM MEDIEVAL TOWN TO MODERN CITY

> Of the Roman legionary base called Eboracum there still remain parts of the wall and the lower portion of a thirteen-sided angle bastion while embedded in the medieval earthen ramparts there is a great deal of Roman walling.
>
> Gordon Home,
> Yorkshire, 1908

Old York is on slightly raised ground above the great floodplain of the River Ouse. While modern development has changed much of the old city, enough remains to provide insights into a remarkable past. York has an historic core that is more intact than that of most towns and cities. Indeed, modern York has thirty-four conservation areas, 2,084 listed buildings, and twenty-two scheduled ancient monuments. A result is that every year, thousands of tourists come to see the surviving medieval buildings, interspersed with Roman and Viking remains and Georgian architecture.

As a city, York dates from the early AD first millennium. However, there is archaeological evidence of people in the area that is now York as far back as perhaps 8,000 BC. Finds of polished stone axes show people during Neolithic times occupying the area where modern-day York now stands. Early settlement was on the south-west bank of the River Ouse, close by today's Scarborough Bridge. Flint tools and weapons near Holgate Beck evidence Bronze Age occupation, with on both sides of the Ouse and in Bootham, burials, a beaker vessel, and bronzes. Later Iron Age burials are on the Ouse south-west bank close to earlier Neolithic axe finds. At Lingcroft Farm, 3 miles (4.8 km) away from York at Naburn, there is a late Iron Age farmstead and by Roman times, York was a major town, the Celtic name of Eboracum or Eburacum occurring in Roman sources. Clearly, from the earliest times, this site was a favoured location for people to settle and live.

The Romans called the tribes around York the Brigantes and the Parisii, York perhaps on the border between the two. During the Roman conquest of Britain, the Brigantes became a Roman 'client state', but, when their leadership became more hostile to Rome, Roman General Quintus Petillius Cerialis led the Ninth Legion to the region north of the Humber to subdue any potential unrest. York was founded in AD 71

when he constructed a military fortress (*castra*) on flat ground above the River Ouse. This was by the confluence with the River Foss. Later rebuilt in stone, the fortress of around 6,000 soldiers extended over about fifty acres. The earliest mention of Eburacum is actually on a wooden stylus tablet dated to *c.* AD 100 and from the Roman fortress of Vindolanda near Hadrian's Wall. Today, most of the Roman fort is under the foundations of York Minster where some of the original walls remain. The site of the Roman baths was rediscovered in 1930 under the tavern in St Sampson's Square, and it has since been open to the public.

> Of the Roman legionary base called Eboracum there still remain parts of the wall and the lower portion of a thirteen-sided angle bastion while embedded in the medieval earthen ramparts there is a great deal of Roman walling.
>
> Gordon Home,
> Yorkshire, 1908

Around AD 120, the Ninth Legion at York was replaced by the Sixth, with no documentation about the Ninth Legion after AD 117. There are various ideas about the fate of the 'lost' Ninth, from annihilation in Scotland to a strategic move to the Mediterranean, the stuff of legends. The Sixth Legion remained in York until the end of Roman occupation, about AD 400, after which the legions withdrew to Rome. The Emperors Hadrian, Septimius Severus and Constantius I all made York their base during campaigns in northern England. It was during his residence that Emperor Severus made York capital of Britannia Inferior, and granted the privileges of a *colonia* or city, one of only four colonias in Britain. Constantius I died in York, and the troops based in York proclaimed his son, Constantine the Great, as Emperor of Rome.

With a major military and administrative presence, York grew in economic importance. Workshops supplied the needs of 5,000 or more troops garrisoned there, with a military pottery, tile kilns, glass working at Coppergate, metal-works, and in Tanner Row leatherworks for the Legion. Trade encouraged local people to develop a permanent settlement on the south-west bank of the Ouse opposite the fortress, and by AD 237, as a *colonia*, this was a thriving centre. These were often established for retired soldiers, and York was self-governing, with a council, wealthy civilians (including merchants) and military veterans. However, around AD 400, York's fortunes deteriorated with the withdrawal of imperial support, the increasing toll of bad weather, and a poor choice of location (i.e. between two flood-prone rivers). The city suffered periodic winter floods from the two rivers, Ouse and Foss. Wharf-side areas with important trading facilities became deep in several feet of silt and infrastructure was not maintained. It seems the main bridge over the Ouse also fell into disrepair. The civilian town dissipated but Eboracum was still an administrative centre. The designated *colonia* was largely above the flood levels but over time was also abandoned with York reduced to small population occupying a thin ribbon of dry land.

Then, in the post-Roman period, Anglo-Saxon colonists arrived, first employed as mercenaries to protect the post-Roman British population. However, they liked what they found and decided to stay and displace the indigenous locals. The modern name of York began to emerge as the Old English Eoforwɪc or Eoforɪc, meaning 'wild boar town' or land 'with plentiful wild boar'. Viking settlers later adapted the name to the Norse 'Jórvík', also interpreted as 'horse bay'. With the Saxon settlement of northern England, York grew into Anglian capital of the region and later of Northumbria. By the early seventh century, York was once more an important royal centre, but this time for Northumbrian Viking

kings. Paulinus of York (later St Paulinus) chose York to establish a timber church, as the forerunner of York Minster, and King Edwin of Northumbria was baptised here in AD 627. It is believed that the first Minster was constructed at around this time, though the exact location is disputed.

> Edwin's wooden chapel, put up in 627 for his baptism into the Christian Church nearly thirteen centuries ago, and almost immediately replaced by a stone structure, has gone, except for some possible fragments in the crypt. Vanished, too, is the building that was standing when, in 1069, the Danes sacked and plundered York, leaving the Minster and city in ruins, so that the great church as we see it belongs almost entirely to the thirteenth and fourteenth centuries, the towers being still later.
>
> Gordon Home,
> Yorkshire, 1908

Over the centuries, which followed, York was established as an important royal and ecclesiastical centre. It gained the appointment of firstly a bishop, and then, from AD 735, an archbishop. Since Saxon settlements were mostly of timber and not stone, and with limited written record, we know little of the city at this time. Under Northumbrian rule however, York grew as a centre of learning, and gained a library and the Minster school. Its most distinguished pupil and then its Master was a man called Alcuin, who later became adviser to the Emperor Charlemagne. Yet little detail is known of this major locus for the kingdom of Northumbria and for Christian learning. Archaeologists suggest that the walls of the Roman fortress have survived reasonably intact with the 'Anglian Tower' filling a gap in the Roman Way, perhaps being a repair undertaken during the Anglian time. With the walls and gates surviving, the layout of Roman streets was intact inside the fortress and the great hall of the Roman legionary building remained in use until the ninth century.

Indeed, by the eighth century, York was once again a bustling commercial settlement with trade links across England, and with Europe, particularly northern France, the Low Countries and Rhineland. Building remains from the seventh and ninth centuries have been found around the confluence of the rivers Foss and Ouse, maybe a trading settlement for the royal and ecclesiastical centres, extending along the River Ouse and on parts of the Foss.

In a turbulent period during the middle of the eleventh century, York was at the centre of the international power struggle. The last king based at York was Eric Haraldsson (c. 885–954), nicknamed 'Eric Bloodaxe' a tenth-century Norwegian ruler, believed to have had short, violent periods as King of Norway and twice as King of Northumbria (c. 947–948, 952–954). Eric's reigns are full of mystery and controversy since the historical sources are rather vague, but at heart a pagan, Eric perhaps converted to Christianity when crowned king at York. He may have died in battle or perhaps even been murdered. A century later, Viking invaders with Northumbrian allies were victorious at the Battle of Fulford, when, on 20 September 1066 King Harald III of Norway (Harald Hardrada) and the banished English Tostig Godwinson defeated the Northern Earls Edwin and Morcar. The tables were turned at the Battle of Stamford Bridge on 25 September 1066, when the English army under King Harold Godwinson routed the invaders. However, this was something of a Pyrrhic victory following the Battle of Hastings and the Norman Conquest which ensued. This turn of events also had major ramifications for York and its people.

An obvious focus of northern identity and independence, York was badly damaged by Norman reprisals to rebellions with the so-called 'wasting of the North'. Nevertheless, the city eventually settled again to become important as the main administrative centre in Yorkshire, one of the major ecclesiastical establishments in England, and a growing urban focus for the region. York flourished throughout the late medieval period with the fourteenth and fifteenth centuries particularly prosperous, though the Wars of the Roses clearly had an impact as the internal struggles of the English monarchy ebbed and flowed. Worse was to follow though during the English Civil War, as what was known to be a Royalist stronghold, York was besieged. Eventually, in 1644, the Parliamentary forces of Lord Fairfax captured the city. Nevertheless, after the problems of the Civil War conflict, York eventually recovered its position and influence in the north, so that by 1660, it was the third-largest city in England following London and Norwich.

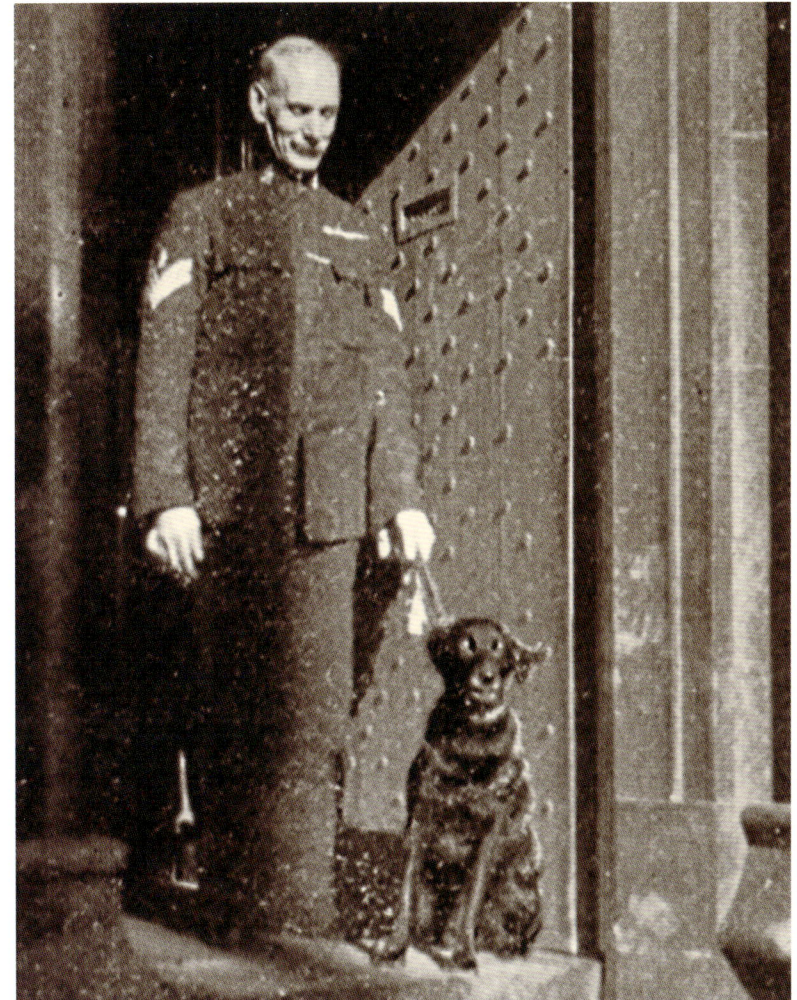

A Minster policeman and his watchdog, 1938.

Above: Acaster Malbis, late 1800s, former historic site.

Above left: A Roman coffin at York.

Below left: A view of York Minster by Mr S. E. Ross, from the 1970s.

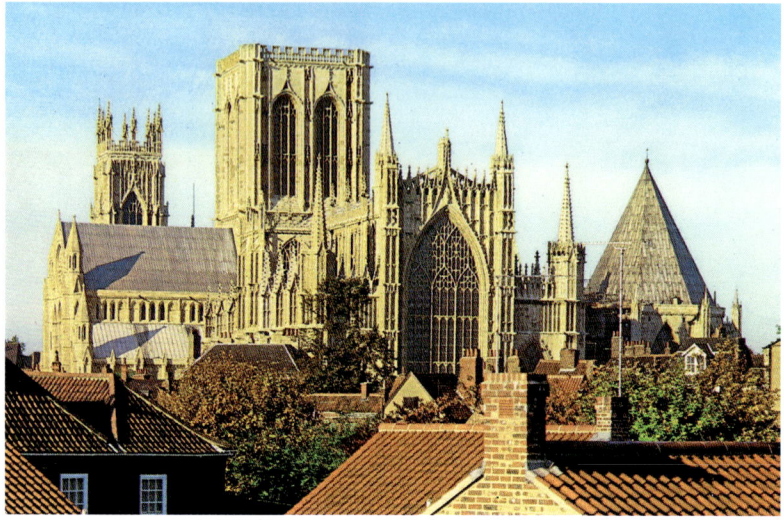

LOST YORK IN COLOUR 17

All Saints Church in the late 1800s.

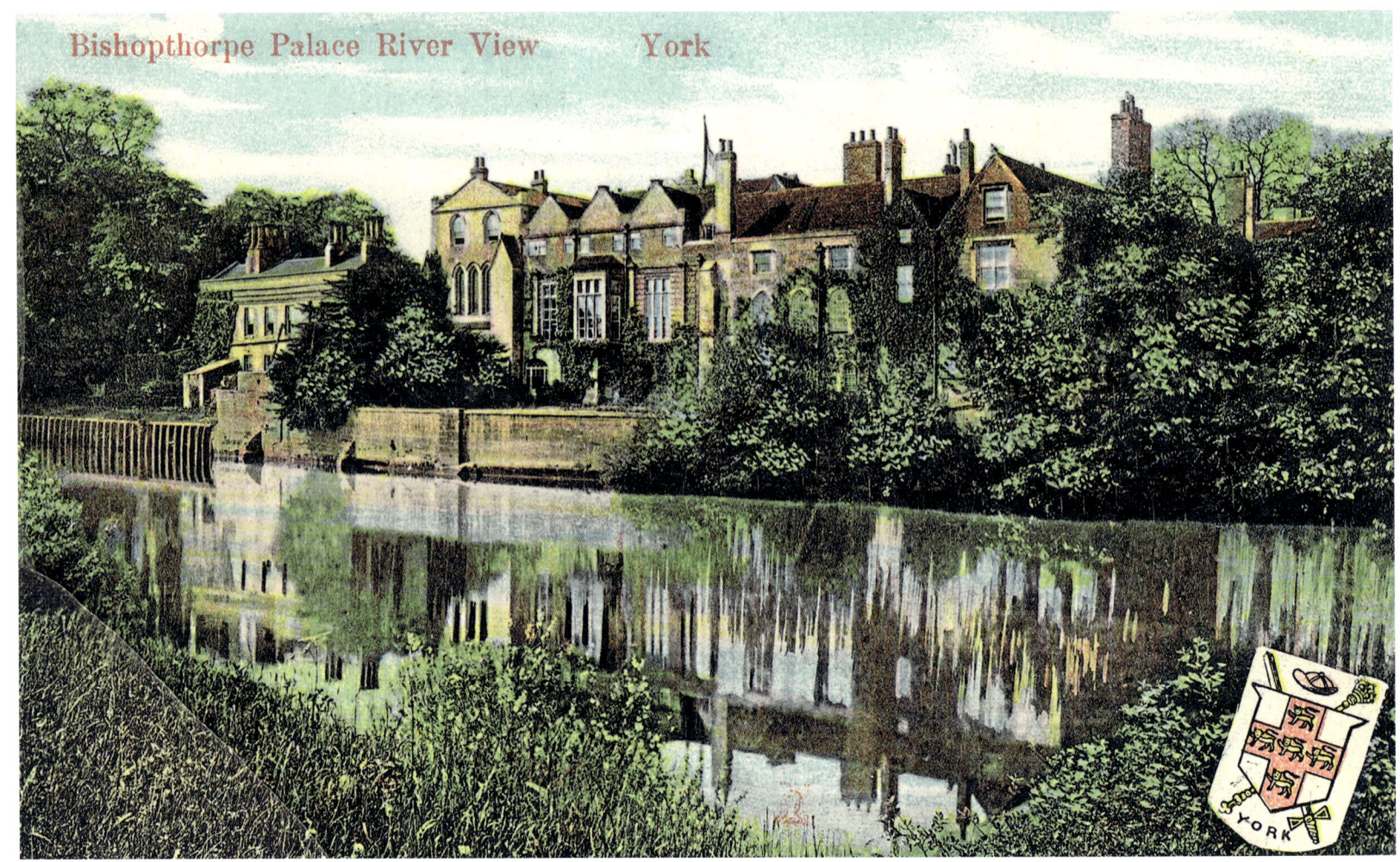

Bishopthorpe Palace, the splendid residence of his Grace the Archbishop of York, shown in the mid-1900s.

LOST YORK IN COLOUR 19

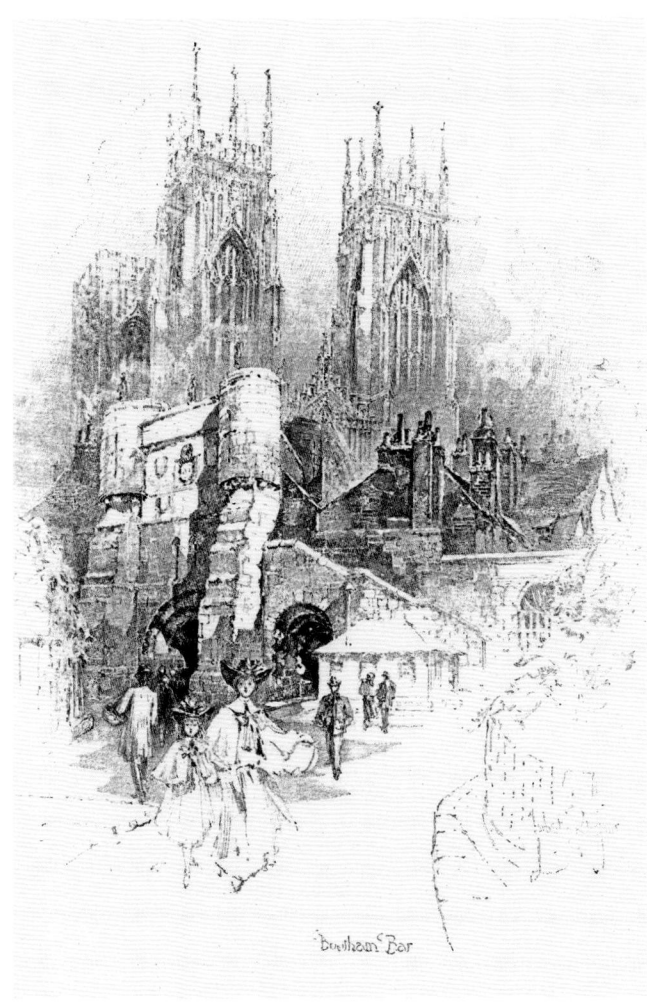

Bootham Bar and the Minster, late 1800s.

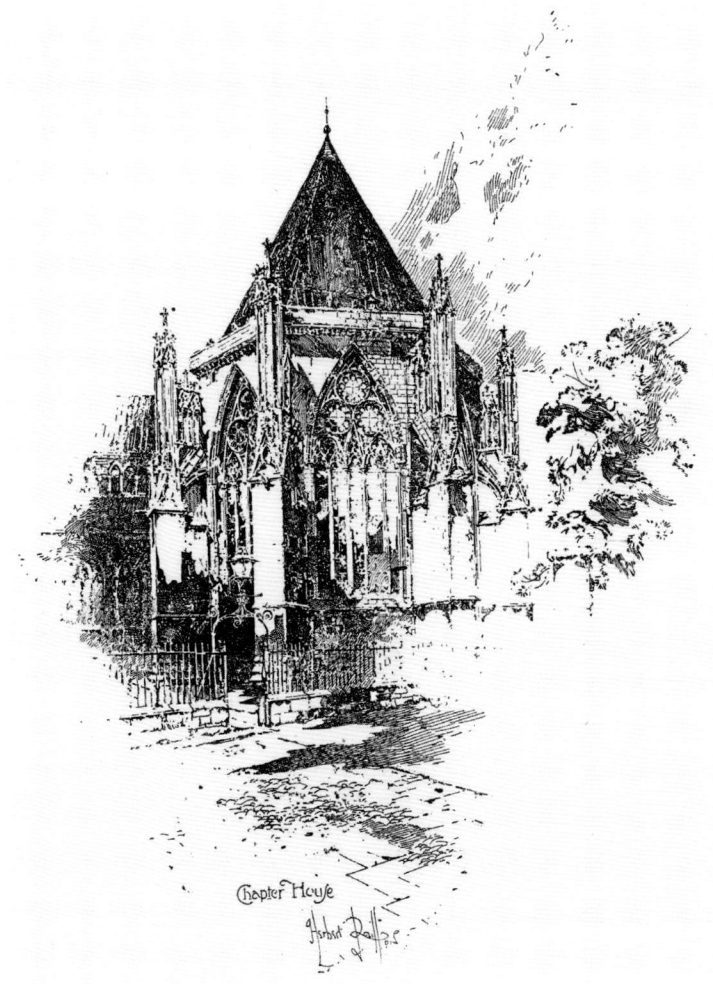

Chapter House, York Minster, late 1800s.

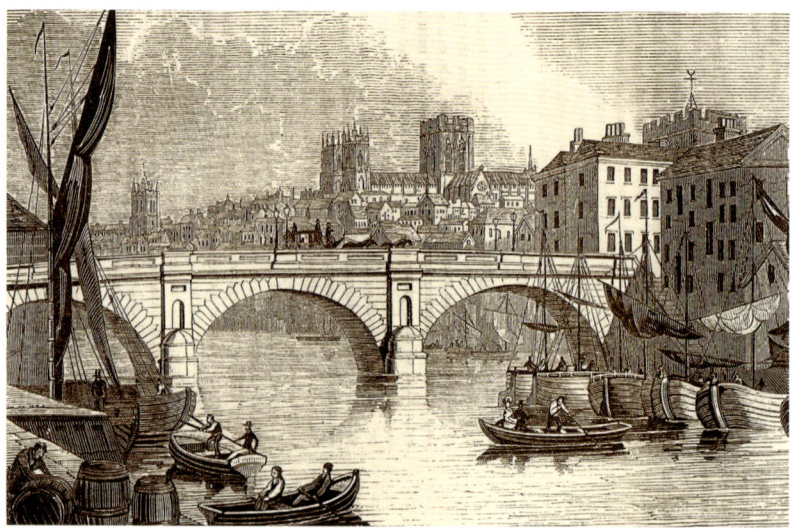

Above: City of York, late 1700s, with hustle and bustle of commercial activities on and around the River Ouse, with sailing boats and rowing boats.

Left: Bootham Bar in the 1840s giving a real impression of the massive medieval defences.

LOST YORK IN COLOUR 21

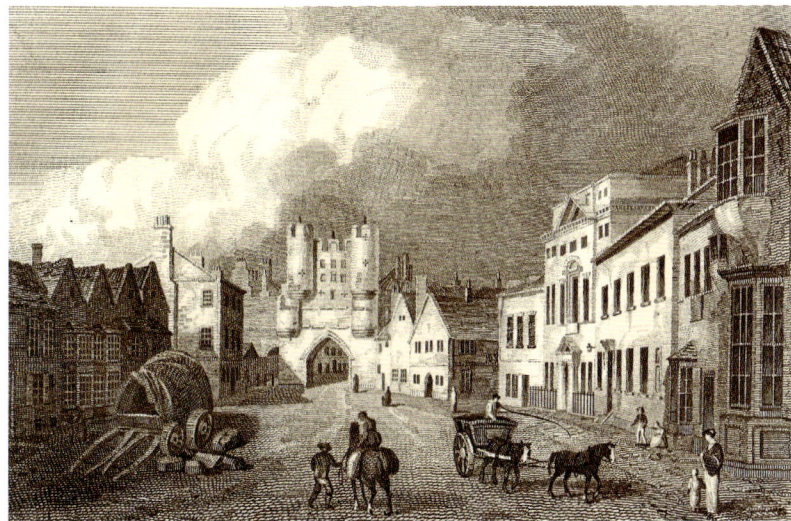

Above: Mickle Gate around 1800 with people on horses and carts.

Right: Micklegate Bar in the 1840s.

Mullion window, Zouche chapel.

North Aisle of the choir, York Minster, late 1800s.

LOST YORK IN COLOUR

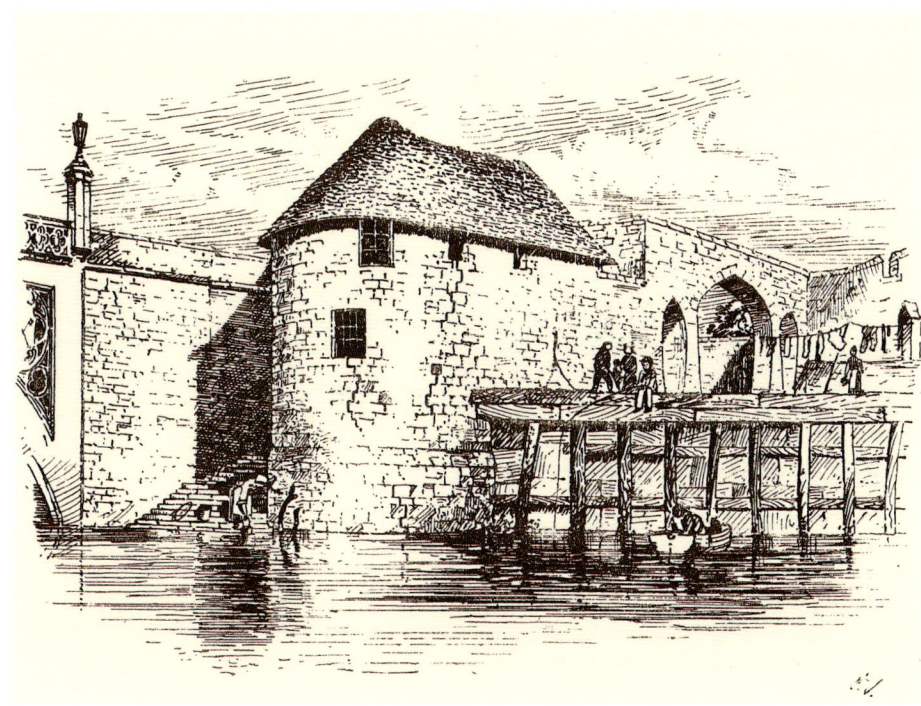

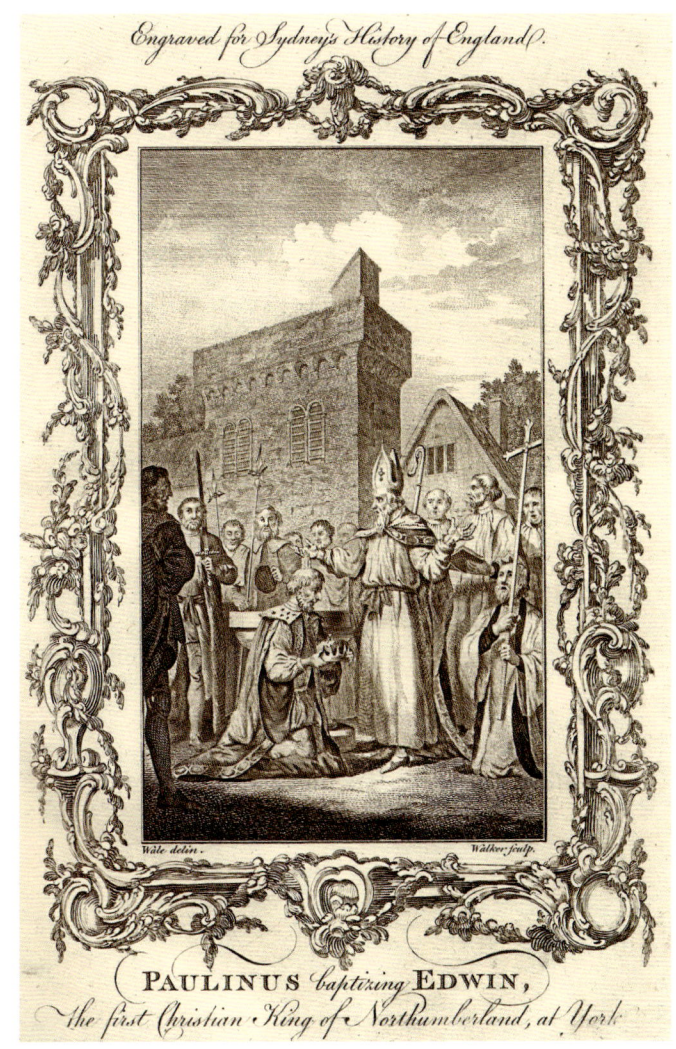

Above: Barker Tower is now the North Street Postern Tower, shown here maybe early 1800s. A chain was once strung across the River Ouse from this point to prevent traders from entering the city without paying a toll and the tower was also defensive. This is the site of a medieval postern gate, enlarged in 1577, re-roofed in the seventeenth century, and replaced in 1840 with a four-centred arch for the Great North of England Railway Co. to give access to its coal yard. It was used as a boom tower and from 1879 as a mortuary. It was restored in 1930, and again in 1970 and is now a shop.

Right: Paulinus at York baptising Edwin as the first Christian king of Northumbria; the city has an amazingly long history as an ecclesiastical centre.

24 LOST YORK IN COLOUR

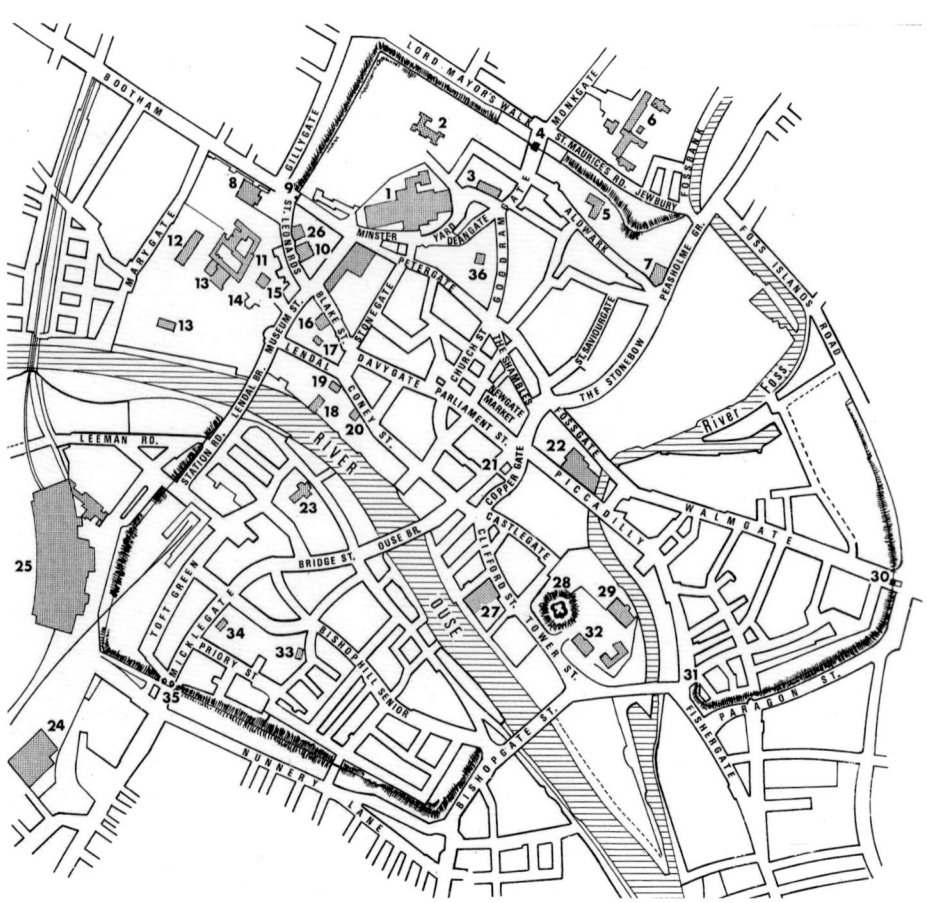

Above: Plan of the city from the 1970s guidebook.

Left: Plan of York Minster in the 1800s.

LOST YORK IN COLOUR 25

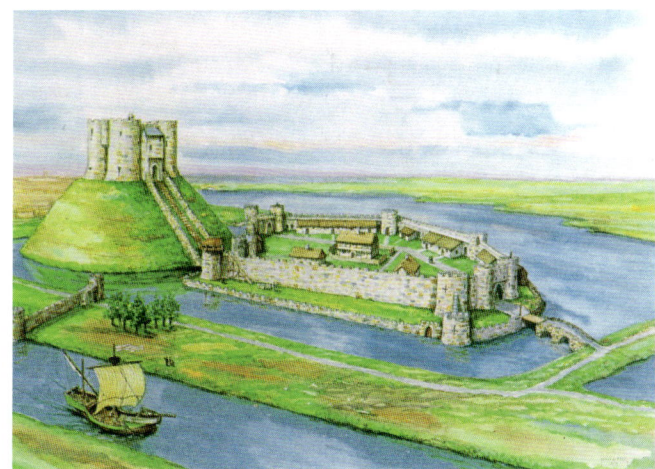

Above: Reconstruction of York Castle around 1400 by Peter Russell.

Right: Plans showing the evolution of the Norman Minster.

PLANS SHOWING THE EVOLUTION OF THE NORMAN MINSTER BUILT BY ARCHBISHOP THOMAS

Remains of a pillar in St Mary's Abbey, late 1800s.

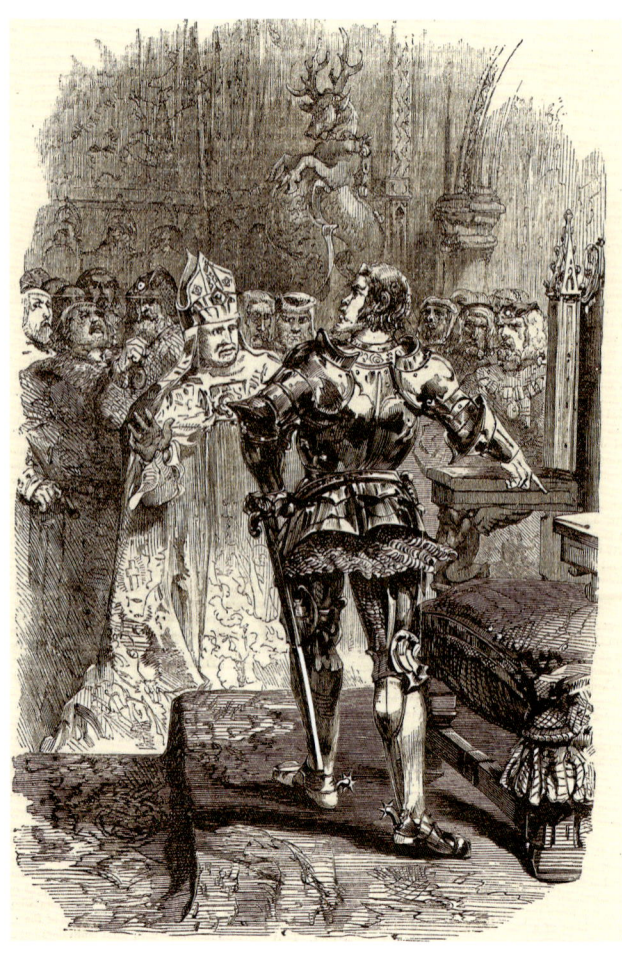

Richard Duke of York claiming the throne in 1455; generally regarded as getting a bad press from Shakespeare and the Tudors, his reputation has been in part recovered. There has also been a campaign to return his body to York.

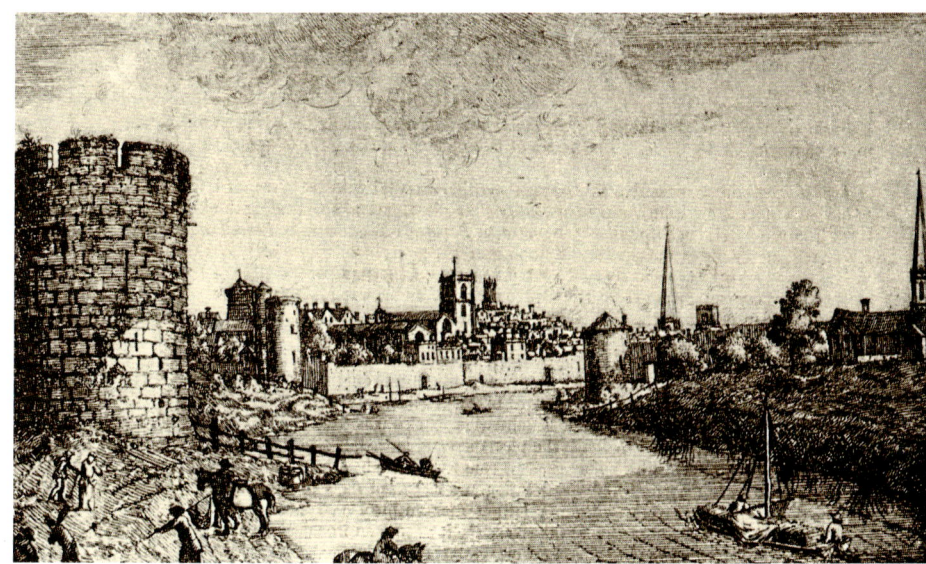

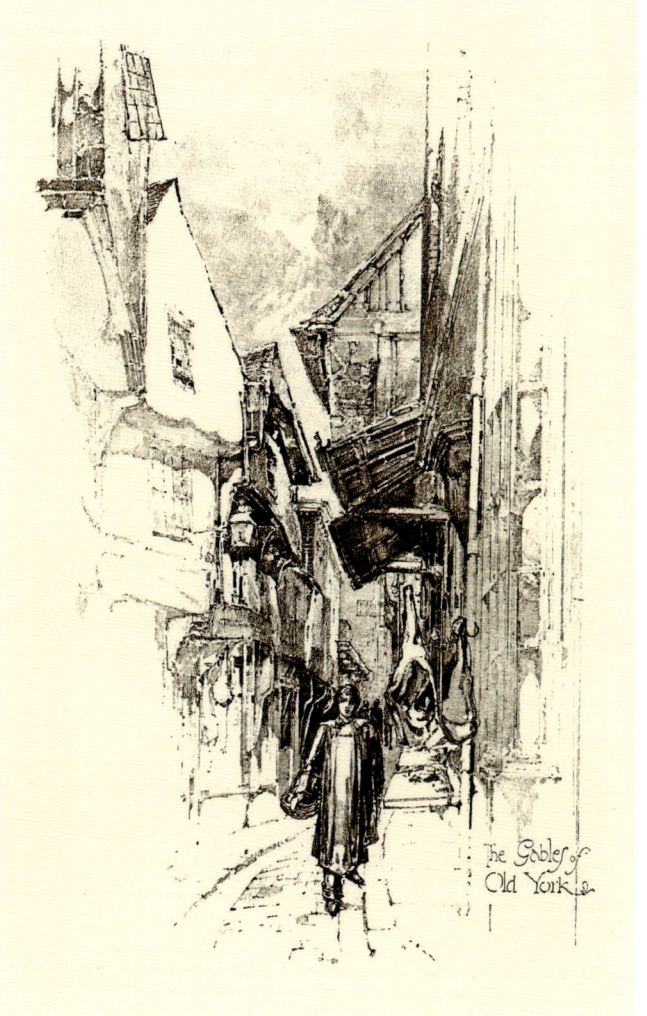

Above: At the south-western corner of the abbey precincts, the Water Tower, built sometime between 1318 and 1324, marks the end of the Marygate walls at the river's edge. It is shown here perhaps in the 1700s.

Right: The Gables of Old York, late 1800s.

28 LOST YORK IN COLOUR

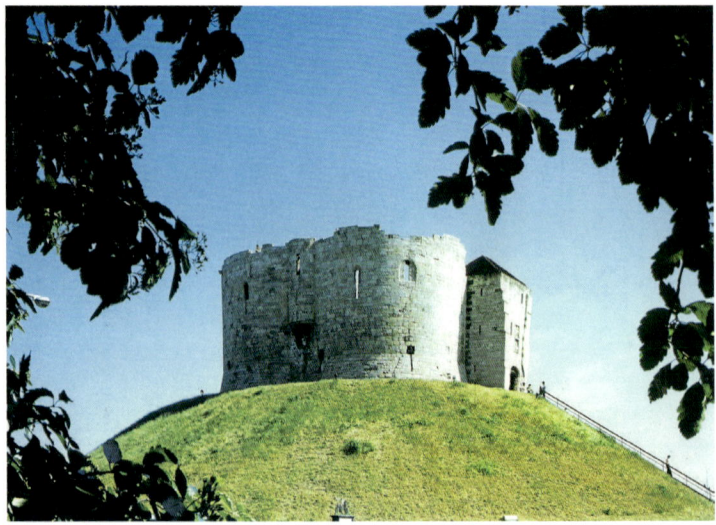

Above: View of Clifford's Tower in the 1970s, the scene of an awful medieval massacre and a dark page in York's history.

Left: Walmsgate Bar from within, late 1800s.

LOST YORK IN COLOUR 29

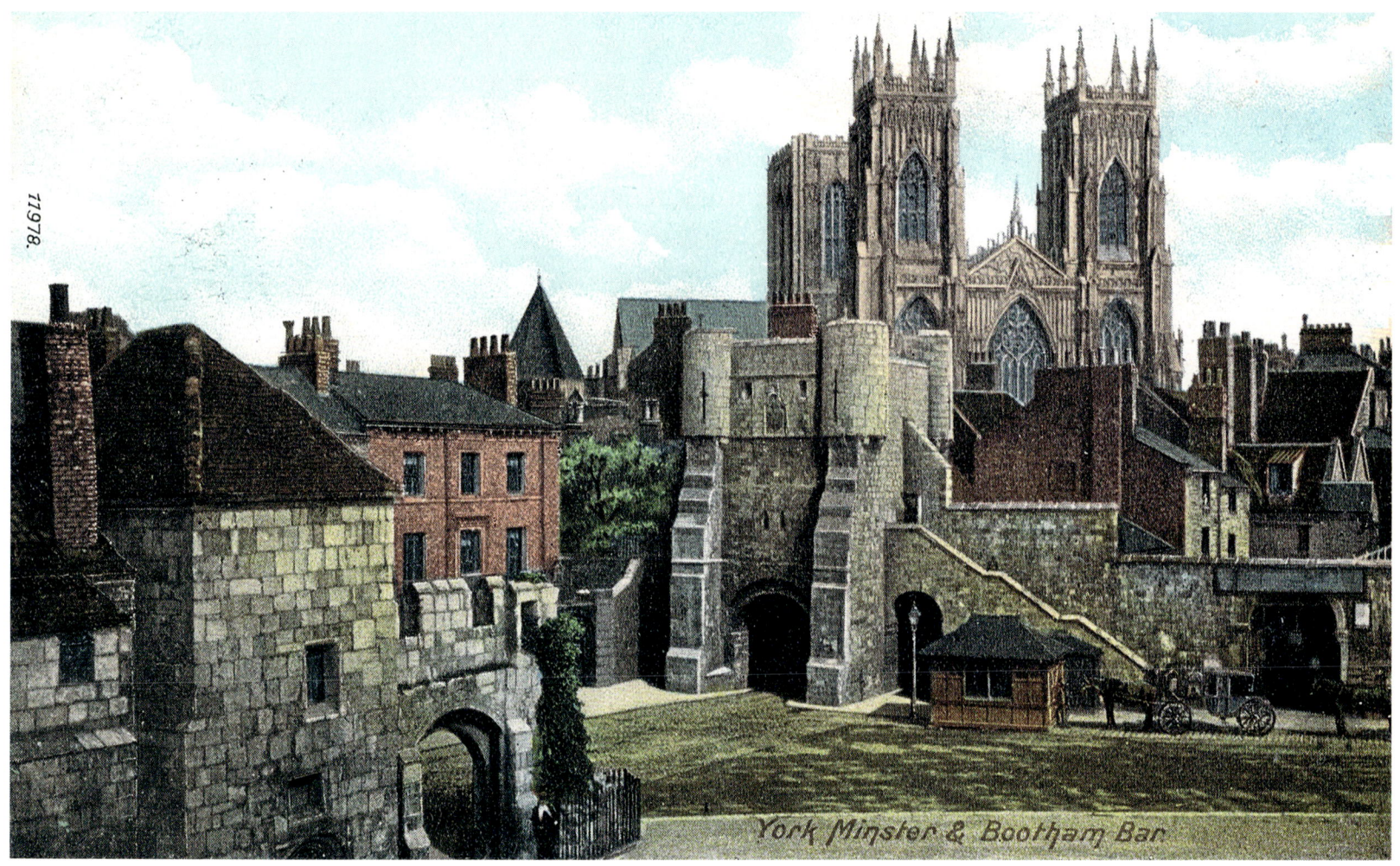

York Minster and the Bootham Bar in around 1908.

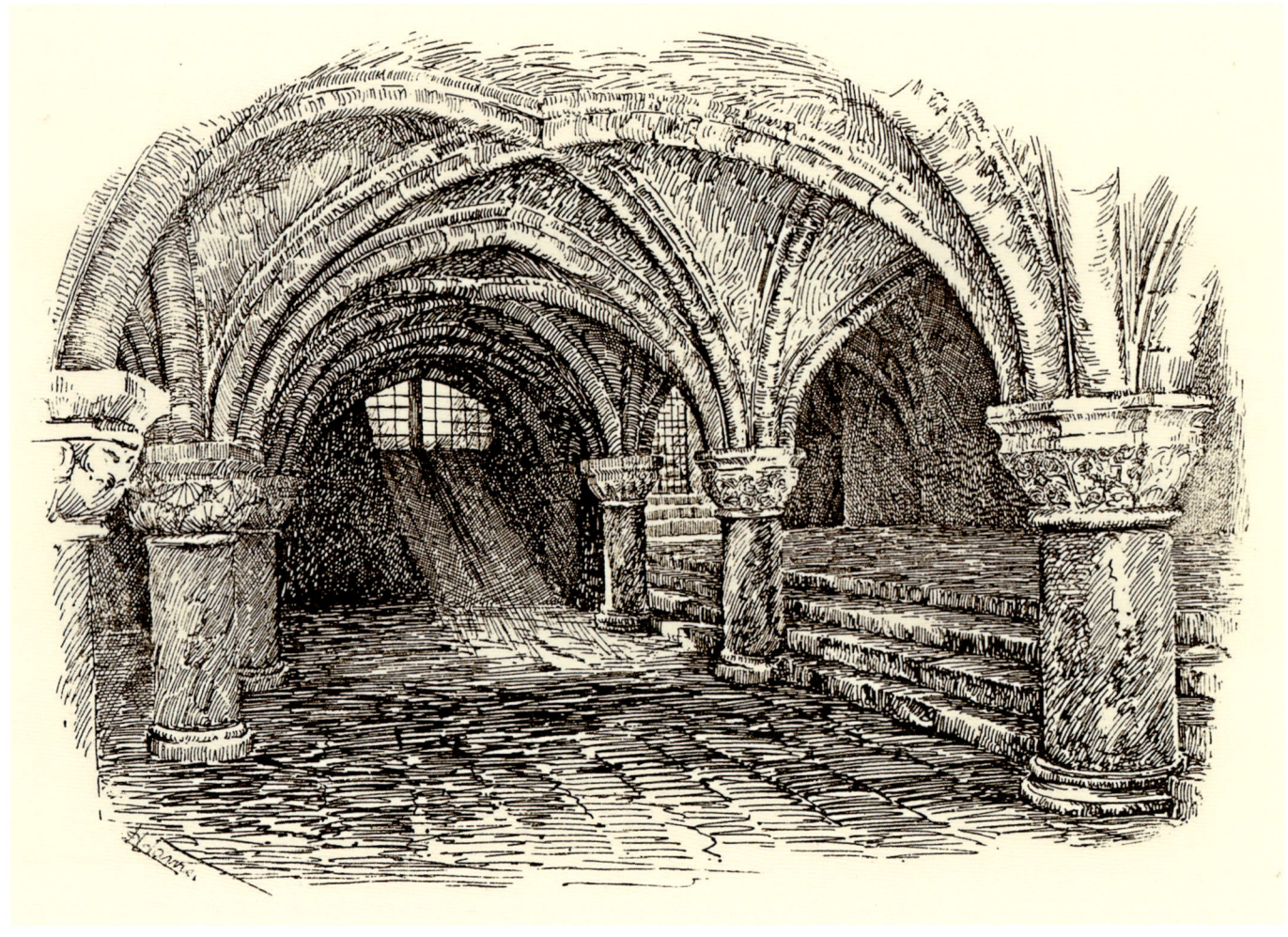

York Minster crypt, late 1800s.

LOST YORK IN COLOUR 31

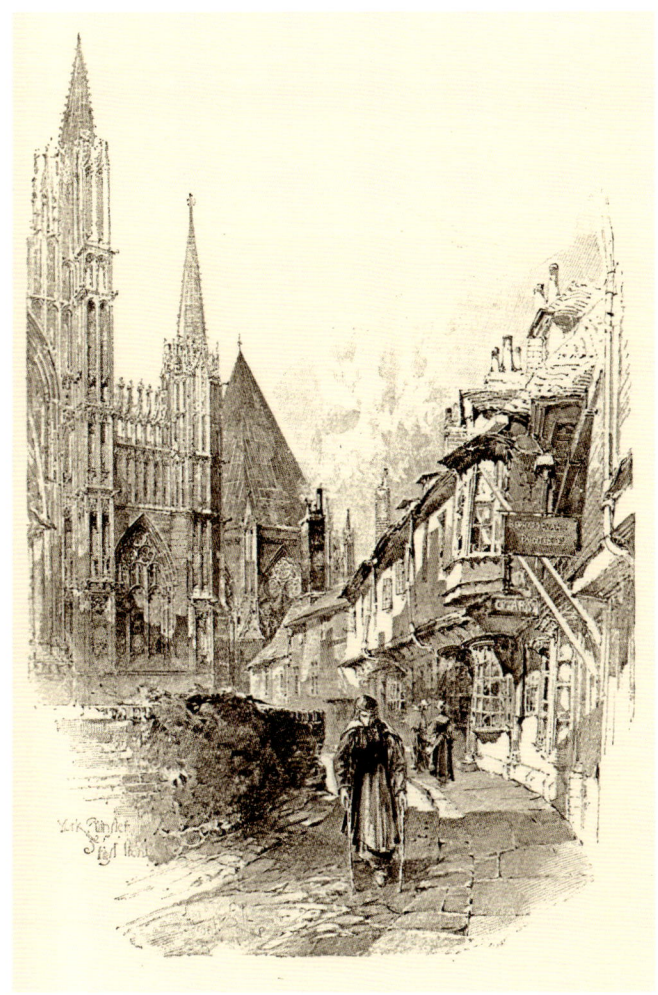

York Minster east front, late 1800s.

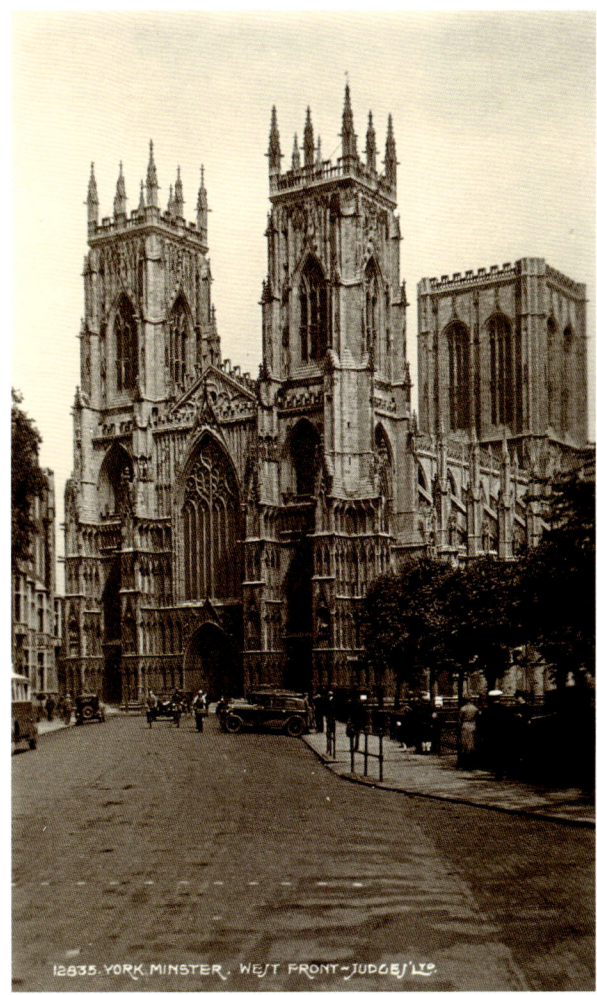

York Minster west front in the early 1920s.

York Minster with the Five Sisters window.

2
INDUSTRY, COMMERCE & URBAN SETTLEMENT

The wall stops short at Skeldergate Bridge, where we cross the river and come to the castle. There is a frowning gateway that boasts no antiquity, and the courtyard within is surrounded by the eighteenth-century assize courts, a military prison, and the governor's house. Hemmed in by these buildings and a massive wall is the artificial mound surmounted by the tottering castle keep. It is called Clifford's Tower because Francis Clifford, Earl of Cumberland, restored the ruined wall in 1642. The Royal Arms and those of the Cliffords can still be seen above the doorway, but the structure as a whole dates from the twelfth century, and in 1190 was the scene of a horrible tragedy, when the people of York determined to massacre the Jews. Those merchants who escaped from their houses with their families and were not killed in the streets fled to the castle, but finding that they were unable to defend the place, they burnt the buildings and destroyed themselves. A few exceptions consented to become Christians, but were afterwards killed by the infuriated townspeople.

Gordon Home,
Yorkshire, 1908

As we see, York's history goes back nearly 2,000 years, to a major centre for Roman government in Britain. In the aftermath of Roman withdrawal, York declined but was reborn under the Saxons and then as Jorvic, the capital of the Northumbrian Vikings. After the Norman harrying of the north in 1069, William the Conqueror, responding to regional revolts, erected two castles either side of the River Ouse. From this base York grew to be the urban administrative centre of the county of Yorkshire, the seat of an archbishopric and an alternative seat of royal government during the thirteenth and fourteenth centuries. Over the period it became an increasingly important trading and commercial centre. Various religious houses were founded during this time, including St Mary's Abbey and the Holy Trinity Priory. However, as a possession of the Crown, York also attracted a substantial Jewish community under the protection of the Sheriff, but this was at a time when Jews were frequently persecuted across Europe. On 16 March 1190, a mob of townsfolk turned on the York Jews so that they fled to the protection of Clifford's Tower. Despite the tower being under the control of the Sheriff, the castle was set alight and the Jews massacred. It is suggested that those in power,

the local magnates under whose protection the Jews were placed, maybe even helped to trigger the massacre and certainly did little to prevent it; perhaps because they too were in debt to the moneylenders. The Clifford's Tower massacre was at a time when there were widespread assaults on the Jewish community in Britain and elsewhere in Europe. In York, the Jewish population recovered after the massacre and remained until 1290 when Jews were expelled from England. Presumably, during the period from the Conquest to the expulsion, the Jewish presence was an important factor in the economic growth of the city.

Then, from an important medieval beginning, York grew through the early industrial period and into the nineteenth and twentieth centuries to become a regional centre for trade, commerce and industry. Many of the factories that drove the modern development of York have since declined, but the city still has a strong commercial and industrial base. Furthermore, this can be traced back to Roman times and then, in pulses of activity, through the Saxon and Viking periods, to the Normans and beyond, a remarkable lineage.

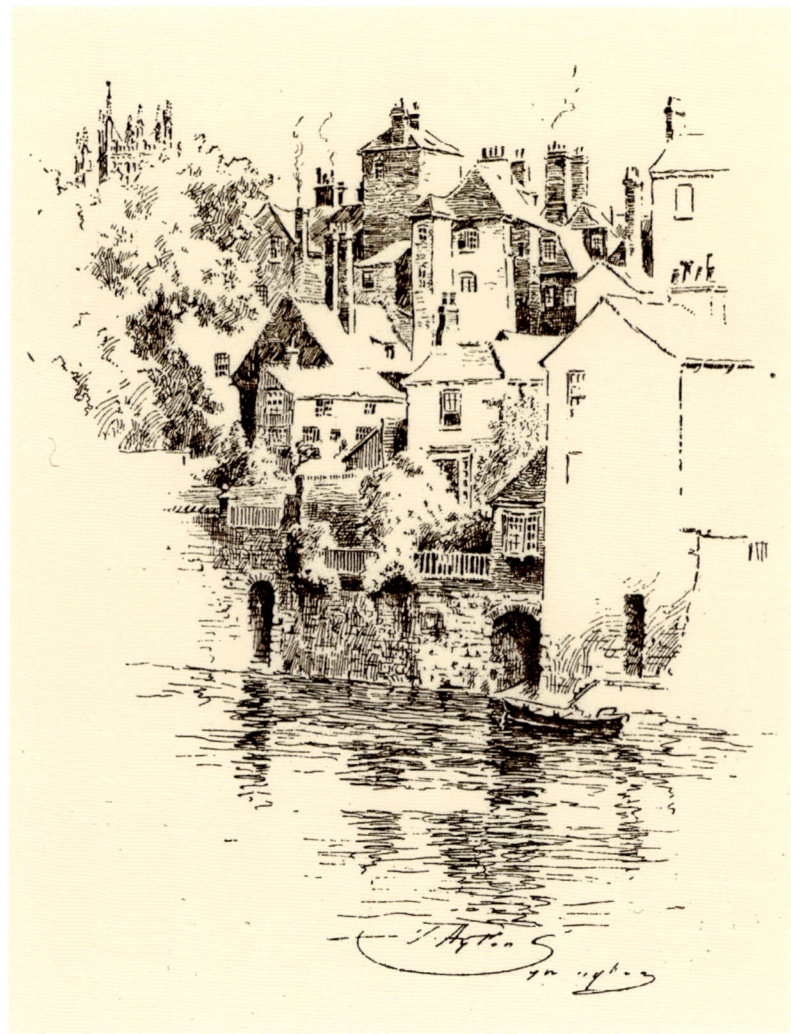

Back of Coney Street, late 1800s.

LOST YORK IN COLOUR 35

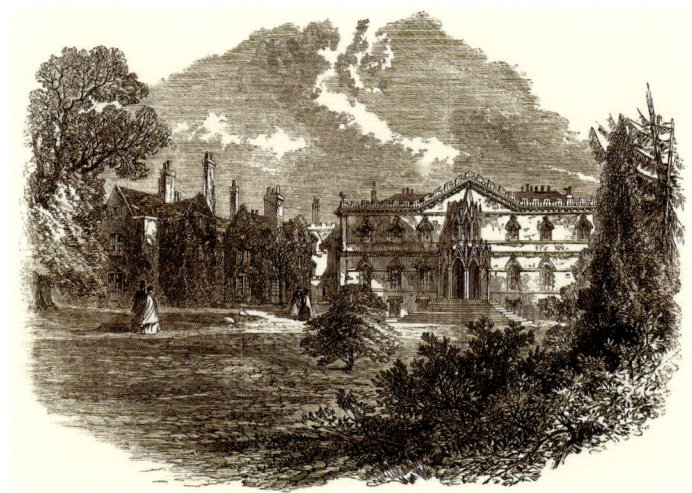

Above: Bishopsthorpe Palace in 1864 visited by the President of the Social Science Congress.

Right: Bishopsthorpe Palace shown in the late 1800s.

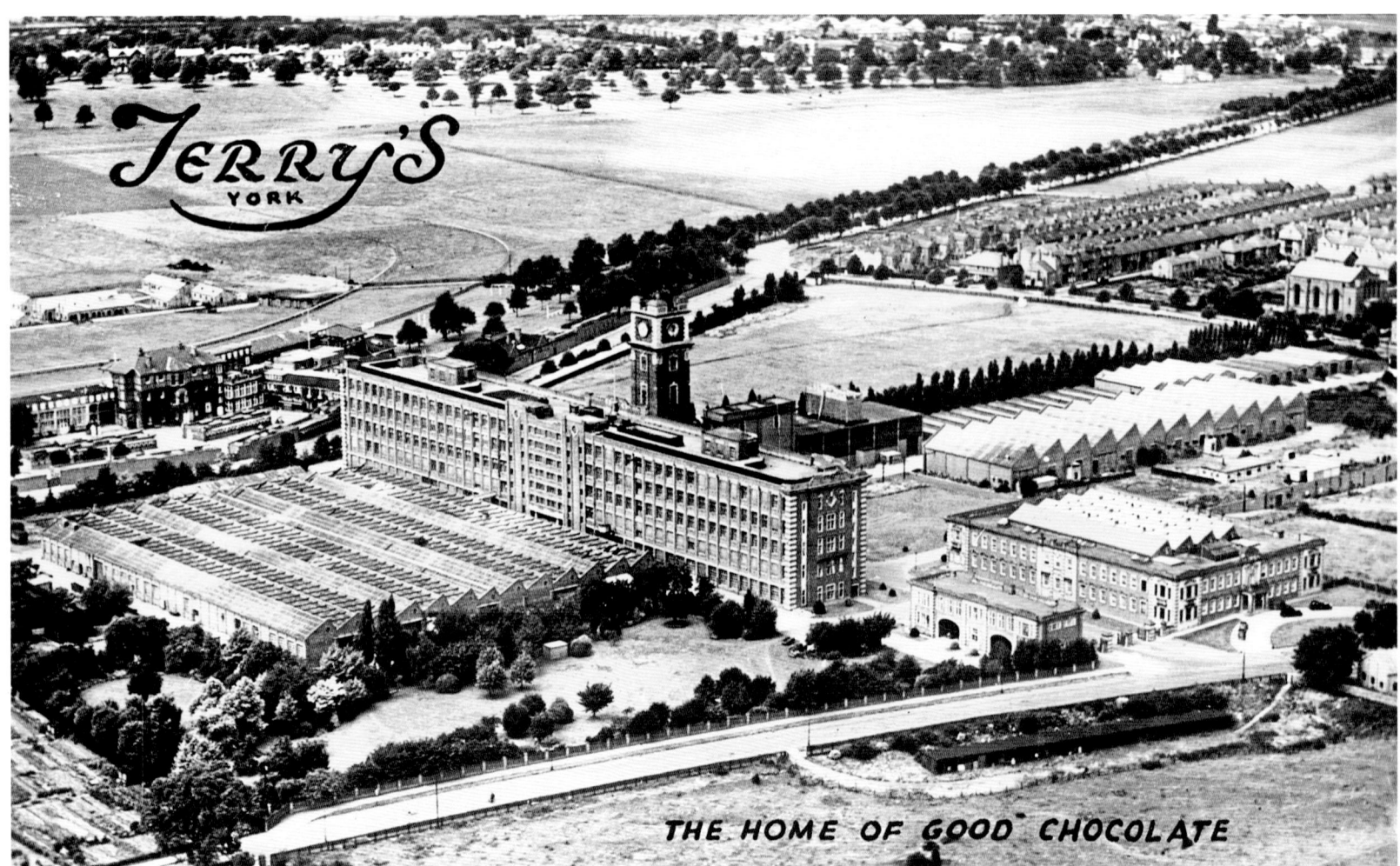

Headquarters of Terry's – Joseph Terry & Sons – 'The Home of Good Chocolate', 1960.

Hudson's House, York, 1849.

Kirkgate at the Castle Museum York, mid-1900s, and a pioneering contribution to York's global tourism reputation.

LOST YORK IN COLOUR 39

Monk Bar in the 1840s.

Above: Monk Bar pictured in the 1840s with sheep, horses and women carrying panniers.

Left: Petergate and York Minster in the 1980s, the street being a long way from its dismal medieval origins.

Above: The Merchant Adventurers' Hall in around 1954 and a symbol of York's growing prosperity.

Right: The Guildhall in the late 1800s with a wonderful view from the river.

42 LOST YORK IN COLOUR

The Treasurer's House dining room, mid-1900s.

LOST YORK IN COLOUR 43

The Treasurer's House drawing room, mid-1900s.

44 LOST YORK IN COLOUR

The Treasurer's House King's bedroom, mid-1900s.

LOST YORK IN COLOUR 45

The Treasurer's House Princess Victoria's bedroom, mid-1900s.

Above: York in about 1600 shows the city in a landscape of rich countryside with the numerous church spires visible.

Left: William and Mary staircase at The Treasurer's House, pictured in the early 1950s.

Above: An evocative view of York by moonlight, in the late 1800s.

Right: The stagecoach to York, in 1706.

YORK Four Days Stage-Coach.

Begins on Friday the 12th of April 1706.

ALL that are desirous to pass from *London* to *York*, or from *York* to *London* or any other Place on that Road; Let them Repair to the *Black Swan* in *Holbourn* in London and to the *Black Swan* in *Coney-street* in *York*.

At both which Places, they may be received in a Stage Coach every *Monday, Wednesday* and *Friday*, which performs the whole Journey in Four Days, (if God permits.) And sets forth at Five in the Morning.

And returns from *York* to *Stamford* in two days, and from *Stamford* by *Huntington* to *London* in two days more. And the like Stages on their return.

Allowing each Passenger 14lb. weight, and all above 3d a Pound

Performed By { Benjamin Kingman, Henry Harrison, Walter Baynes.

Also this gives Notice that *Newcastle* Stage Coach, sets out from *York*, every Monday, and Friday, and from *Newcastle* every Monday, and Friday.

YORK COACHING DAYS.
FAC-SIMILE OF THE COACHING NOTICE IN 1706.

York view from the Pavement, late 1800s.

3
THE CITY OF YORK AS A CENTRE FOR RICH FARMING LANDSCAPES & FOR LOCAL PEOPLE

The narrowest and most antique of the old streets of York are close to All Saints' Church, and the first we enter is the Shambles, where butchers' shops with slaughter-houses behind still line both sides of the way. On the left, as we go towards the Minster, one of the shops has a depressed ogee arch of oak, and great curved brackets across the passage leading to the back. All the houses are timber-framed, and either plastered and coloured with warm ochre wash, or have the spaces between the oak filled with dark red brick. In the Little Shambles, too, there are many curious details in the high gables, pargeting and oriel windows. Petergate is a charming old street, though not quite so rich in antique houses as Stonegate. A large number of shops in Stonegate sell 'antiques', and, as the pleasure of buying an old pair of silver candlesticks is greatly enhanced by the knowledge that the purchase will be associated with the old-world streets of York, there is every reason for believing that these quaint houses are in no danger. In walking through these streets we are very little disturbed by traffic, and the atmosphere of centuries long dead seems to surround us.

<div style="text-align: right;">Gordon Home,
Yorkshire, 1908</div>

York prospered during much of the later medieval era and this is reflected in the built environment and, particularly, the numbers of churches. Indeed, twenty medieval parish churches survive in whole or in part, though only eight of these are now regularly used for worship. The medieval city walls, with their entrance gates, known as bars, encompassed virtually the entire city and survive to this day. The city was also designated as a county corporate, giving it effective county status.

The later years of the fourteenth, and earlier years of the fifteenth centuries were particularly prosperous. During this time, the York Mystery Plays performed by the craft guilds of the city evolved as a regular cycle of religious pageants associated with the Corpus Christi cycle. From the late fifteenth century York entered something of a decline in regional and economic importance. An attempt to lift civic confidence during this period was the construction of a new guildhall in the mid-1400s. There are other well-known features of York from this time like the Shambles, a street of timber-framed butchers' shops, now a popular tourist attraction, dating from late medieval. Look carefully and you can see the butchers' outdoor shelves and meat hooks. The function has changed and these are mostly souvenir shops for York's massive tourism industry. For a

long time after the completion of the Minster in 1472, there were only a limited number of new buildings of note, exceptions being the King's Manor where from 1537 to 1641 the Council of the North was based, and the reconstruction of the church of St Michael le Belfrey. (Interestingly, it was here that Guy Fawkes was baptised in 1570.)

During the middle sixteenth century, another bombshell struck with the dissolution of the monasteries under Henry XIII. All York's monastic institutions were shut down, including St Leonard's Hospital and then, in 1539, St Mary's Abbey. By 1547, as the York's population fell, fifteen parish churches closed, so the overall number reduced to twenty-five from forty. With the English Reformation, practising Roman Catholicism became illegal. However, a strong Catholic presence remained in the north, especially among some of the nobility, and a clandestine Catholic community remained in York. Catholics in York included St Margaret Clitherow, executed in 1586 for harbouring a priest. Guy Fawkes was also associated with the network and, while not a Catholic himself, was executed for his part in the Gunpowder Plot in 1605. There were troubled times and as the schism with Parliament grew, for six months in 1642, King Charles I set up his court in York. The ultimate result for the city was a siege and defeat to the Parliamentarians. Later in the same century, still with anti-Catholic laws, the Bar Convent was established in York, but in secret, the oldest surviving convent in England.

Built between 1711 and 1726, the Judges' Lodgings is now a Grade I-listed townhouse. It was used to house judges when they attended the quarterly sessions of the York Castle Assizes. Indeed, as a major administrative and legal centre, York held a number of notorious villains and was the place of their trial and punishment. One of the most infamous was highwayman Dick Turpin who, on 22 March 1739, was convicted at the York Grand Jury House. He was found guilty of horse stealing and taken to be hanged at the Knavesmire on 7 April 1739. Turpin's body was buried in the churchyard of St George's Church, and the gravestone includes his alias name of John Palmer.

There is an open space faced by Bootham Bar, the chief gateway towards the north; behind are the weathered red roofs of many antique houses, and beyond them rises the stately mass of the Minster. The barbican was removed in 1831, and the interior has been much restored, without, however, destroying its fascination. We can still see the portcullis and look out of the narrow windows through which the watchmen have gazed in early times at approaching travellers. It was at this gateway that armed guides could be obtained to protect those who were journeying northwards through the Forest of Galtres, where wolves were to be feared in the Middle Ages.

Gordon Home,
Yorkshire, 1908

Above: A breezy day in old York, in the early 1900s and causing havoc in the marketplace.

Above right: Farmers' wives selling produce at York Saturday Market in the 1960s.

Below right: Fertiliser experiments and marketing from Derwent near York in 1903; the city is centred in a rich farming landscape.

Above: The Guildhall and the River Ouse in the early 1900s.

Left: The Lady Chapel, York Minster.

LOST YORK IN COLOUR 53

View across York with pollard trees and the Minster in the distance, 1800s; the withies would be cut for local basket-making.

Yorkshire Agricultural Society Show, July 1924.

4
A RICH CITY OF INFLUENCE IN THE NORTH

Its bold turrets are pierced with arrow-slits, and above the battlements are three stone figures. The archway is a survival of the Norman city. In gazing at this imposing gateway, which confronted all who approached York from the south, we seem to hear the clanking sound of the portcullis as it is raised and lowered to allow the entry of some Plantagenet sovereign and his armed retinue, and, remembering that above this gate were fixed the dripping heads of Richard, Duke of York, after his defeat at Wakefield; the Earl of Devon, after Towton, and a long list of others of noble birth, we realize that in those times of pageantry, when the most perfect artistry appeared in costume, in architecture, and in ornament of every description, there was a blood-thirstiness that makes us shiver.

<div style="text-align: right;">Gordon Home on the Micklegate Bar,
Yorkshire, 1908</div>

In early medieval times, York emerged as a strategic crossing point on the River Ouse. It was sufficiently far north for royal visits, a stronghold of power in northern England and a base for the Council of the North. Location was an important consideration in a medieval England often torn apart by civil strife and unrest, and with the ever-present threat of incursions from the Scots to the north. The River Ouse provided an artery for water-borne transport to allow movement of materials into and out of the city, with manufactured goods carried downstream and for export around Britain and into Europe. Today, the Ouse, the Derwent, and their associated nature reserves are havens for diverse birdlife including cormorants, kingfishers, egrets, herons and other water birds, for fish such as trout, eels, grayling and others, and for mammals such as otters, roe deer, and water voles. Wheldrake Ings to the south of York is one of the richest wildlife sites in Britain. The modern landscape and countryside are very different from times past, when the hinterland of York had to provide for a rich and bustling city. Farmers, tradesmen, craftsmen and shopkeepers would have flocked to York in droves, to work, to sell their wares and to buy produce. The city grew as a cultural and ecclesiastical centre, as an administrative base, and as an important political and military stronghold.

One little-known trade in York was the selling of peat fuel or turf for the hearths of the great city. As far back as the Romans, York was

fuelled by peat from turbaries at Askham Bog and at nearby Tillmire. While it is thought that coal from around modern-day Leeds was being burnt in Roman York, for peat there is little direct evidence. In 1388, peat or turbarum was being brought into York by water to supplement the city's own turbary on the Tillmire near Heslington. Peat was no longer available from other sites on the main rivers near York, so additional supplies were needed including all the way up the Ouse by barge and from as far away as Thorne Moors near Doncaster. By the medieval period, peat turf was documented on the streets of York. Indeed, the court rolls provide an insight to the medieval trade as peat sellers were prosecuted for selling at the wrong price on the streets of York. In 1643, nine men were accused of 'selling turfs contrary to my Lord Mayor's price'. Admitting guilt, they were fined ¾ pence each '… according to an Order made in the like case the 9th day of November 1593'. This latter reference was to four men reprimanded and fined for a similar offence. In the 1643 entry for fines paid to the Corporation of York it is stated that money was received as '… of watermen for selling turves before the price was sett by my Lord Mayor 8/-'. Reference to the month of November suggests a time when the cold made turf particularly important.

Bishopthorpe Palace in the early 1920s, overlooking the river.

> When Henry VIII paid his one visit to York it was after the Pilgrimage of Grace led by Robert Aske, who was hanged on one of the gates. The citizens who had welcomed the rebels pleaded pardon, which was granted three years afterwards; but Henry appointed a council, with the Duke of Norfolk as its president, which was held in the Abbots' house, and resulted in the Mayor and Corporation losing most of their powers.
>
> Gordon Home,
> Yorkshire, 1908

Bishopthorpe Palace, York, the residence of his Grace the Archbishop of York, mid-1900s.

58 LOST YORK IN COLOUR

Bootham Bar in the early 1900s.

Goodramgate Holy Trinity Church, early 1900s.

60 LOST YORK IN COLOUR

Ruins of St Mary's Abbey, late 1800s.

Ruins of the North Aisle of St Mary's Abbey, late 1800s.

Above: As the city grew, then so did the splendour of its civic events – the Lord Mayor's Banquet, York, 1873, and the Lord Mayor's Table.

Right: Stonegate, York in the late 1800s.

62 LOST YORK IN COLOUR

Reception of the Lord Mayor of London, The Lord Mayor's Banquet York, 1873.

LOST YORK IN COLOUR 63

Procession to the dinner led by the Lord Mayor of York, The Mayor's Banquet at York, 1873.

Above: York Minster from the river *c.* 1800 with sailing boats and rowing boats beached on the riverbank.

Left: Dinner with the Lord Mayor and Mayors, The Mayor's Banquet at York, 1873.

5
VICTORIAN SQUALOR & POLLUTION

Throughout the nineteenth century, York continued to thrive and to grow. George Hudson, known as the 'Railway King' had a major influence in making York an important centre for the railway network though the 1800s and into the mid-twentieth century. The world-famous Railway Museum reflects this remarkable lineage. As the economic core of York expanded, so did its housing estates, and today the modern city boasts desirable, green suburbs. There were Victorian slums and poverty aplenty, but modern York exhibits little of evidence of this today; most were demolished during the early to mid-twentieth century.

Yet the Rowntree presence in York is a reminder of this grimy past. In 1901, B. S. Rowntree published *Poverty: A Study of Town Life*, the results of his researches in York. In essence, Rowntree calculated what a typical working-class family needed to spend in order to survive. He then investigated what people in York earned and found that nearly 10 per cent lived in 'primary poverty' and 18 per cent in 'secondary poverty'. With the city characterised by acute over-crowding and squalor in late Victorian York, nearly 30 per cent of the population barely had enough resources to stay alive. Furthermore, York was as badly off in terms of its poor as was London. To keep a family of husband and wife plus three children, a man needed to spend between 18*s* and 21*s* a week, and this would provide a diet worse than that in the Workhouse. These harsh observations shocked Rowntree's contemporaries. The Rowntree business became one of the great philanthropic institutions of the era.

However, while this poverty is long gone and little talked about, there was a distinctly seedy side to Victorian York and Frances Finnegan, writing in 1979, provided a fascinating insight into the city's underbelly. Streets like Lower Wesley Place ran down to the right bank of the River Foss, and throughout the nineteenth and early twentieth centuries were vulnerable to frequent floods. Furthermore, the river was at that time a 'great open cesspool into the stagnating waters of which the sewers of nearly half the city sluggishly pass'. To make matters worse, around St Margaret's Church on Walmgate was one of the city's large dung-heaps and the liquor from this also drained into the Foss. With pitiful pay even for those in work, awful conditions, squalor, disease and lack of sanitation, tenement areas like Wesley Place were centres for prostitution. Of an occupied female population in the 1840s and 1850,

of perhaps 3,000, around 170 or more were known prostitutes, a further 320 were 'suspected persons', and there were around ninety 'houses of ill-fame' and about 325 of 'bad character'. This was in a town of only 26,260 in 1831, rising to 49,530 in 1881.

That there was prostitution on such as large scale in an historic and seemingly genteel cathedral city requires some careful consideration. The causes of the problem, were, as Finnegan observed, the low wages and lack of opportunities. The vast majority of working-class women were in domestic service or charwomen, and York's status as a city to visit for business, for the church, or as tourists compounded the problems. Poverty provided the cause and the large numbers of transient visitors the opportunity. This desperate history left something of a legacy in York as it did in some other towns and cities, with street names and place-names, though many since made more polite. So near Finkle Street was 'Mucky Peg Lane', and Grape Lane near the Minster was formerly 'Grope-**** Lane'. Another site for plying the trade was St Andrewgate, and an indication of the state of affairs back to the sixteenth century was the conversion of the partially demolished church (from which the street got its name) to a common brothel. York sucked people in but there was little real industry to employ them. By the 1860s, there was even a York Society for the Prevention of Youthful Depravity, but the records also suggest that one in six identified clients was a policeman.

Grape Lane was a more polite name than the medieval and early Victorian association with ladies of the night than its original name.

LOST YORK IN COLOUR 67

Above: Lower Wesley Place, a centre for prostitution which led down to the River Foss and, at times, up to the early 1900s, was virtually an open sewer.

Right: Mucky Peg Lane in the 1800s, a centre for squalor, dirt and prostitution.

68　LOST YORK IN COLOUR

The wonderful, hump-back Ouse Bridge, demolished in 1809.

LOST YORK IN COLOUR 69

Petergate around 1908 with a feel of old medieval York.

Petergate was a favourite haunt of Victorian prostitutes seeking clients.

Above: York Minster has been struck by catastrophic fires twice. This was the disastrous fire at the Minster in 1840.

Right: Stonegate York in around 1905 with horse and cart and shoppers.

Above: The old Ouse Bridge, in around 1800.

Left: The entrance to the Merchants' Hall in the early 1900s.

LOST YORK IN COLOUR 73

THE OUSE BRIDGE

Above: The Ouse Bridge, late 1800s.

Right: The rather grim looking Stonebow Lane from Hungate, the premises being Victorian brothels owned by a local police inspector.

The Shambles, late 1800s.

A great view of the Shambles to capture the medieval heart of old York.

LOST YORK IN COLOUR 75

View of York in the early 1800s with the river and its pastoral landscape.

York from the River Ouse in the 1800s showing towers, walls, and the Minster beyond.

LOST YORK IN COLOUR 77

A lovely view of the Minster from the walls in the late 1800s.

York Minster, late 1800s.

Above: An evocative view of the York Shambles in the early 1900s.

Left: Shoppers along the York Shambles pictured in the early 1900s.

6
EDUCATION, HEALTH & THE ARTS

York has long been a centre of ecclesiastical work and training and, associated with these, has become a focus of learning and scholarship in Britain and in Europe. With its great importance as a medieval administrative centre, York would always have had good provision for the needs of the city and the region. However, as the industrial city grew, the requirements to provide for the education and improvement of its population became obvious. The need for specialist skills, training and research for the new industries leading York's industrial revolution meant schools, colleges, universities, libraries and art galleries all flourished. Then, with rising population, there was the demand for improved health care and hospitals.

With more people, there was a need to provide other essential services such as schooling but also health care. With the dissolution of the monasteries, much of the limited infrastructure for care of the sick and the poor had been destroyed. However, in 1740, with a growing urban population, York's first hospital, York County Hospital, opened in Monkgate. Demand was so great that in 1745, funded by public subscription, it moved to bigger premises. The hospital was further expanded in 1851, and remained open until 1976 when it was replaced by York District Hospital. Mental health was also a problem for a city on this scale, and the care of the sick was challenging and often left to individuals or to charitable bodies. In 1796, for example, the Quaker William Tuke founded 'The Retreat' as a pioneering hospital for the mentally ill that was located in east York beyond city walls. It claimed to use 'moral treatment' as developed by Tuke, which emphasised 'clean living', benevolence and religious morals and was in sharp contrast to popular therapies like bloodletting or purging. Treatment of the mentally ill or insane was generally appalling and involved restraint within an asylum. By the late 1800s, a Rescue Home for Fallen Women was set up in Skeldergate to provide immediate shelter, and at Bishophill there was a long-term Refuge or Female Penitentiary. On Trinity Lane there was a third institution, The Home for the Friendless and Fallen.

As a major religious centre and despite issues of conformity and persecution over the centuries, York has benefitted from the charitable works of Christian communities, an example being The Bar Convent. This is now open as a museum, shop and café, with guest house

accommodation, meeting rooms and conference facilities. Founded in 1686 by Frances Bedingfield, an early member of Mary Ward's Institute, it was a base for the Congregation of Jesus Community. The Convent has bequeathed a rich heritage relating to York, its community, and the church. The immediate need, according to Sir Thomas Gascoigne was for '... a school for our daughters'. Initially a boarding school for Catholic girls, by 1699 there was a free day school. By the late twentieth century the schooling tradition was maintained via a grammar school and then All Saints Catholic Comprehensive School. The seventeenth-century house bought by Frances Bedingfield was replaced by the fine eighteenth-century century Georgian buildings (Grade I-listed) seen today.

Above: Arms of the Earl of Strafford, at the York Blind School, late 1800s.

Left: Aerial view of University of York Campus at Heslington in the 1970s and part of an economic and cultural revolution in the city.

LOST YORK IN COLOUR 81

Above: College Street in the 1930s.

Right: Entrance to the York Blind School, late 1800s.

Above: The Chapel at St Mary's Convent in the early 1900s.

Left: St William's College York, late 1800s.

The new Soldiers' Institute at York, 1887.

The Quadrangle at the Blind Institution in the former palace of the Stuart kings, pictured in the 1920s.

LOST YORK IN COLOUR 85

View of York along the river to the old bridge, 1756.

York from the Ouse in the early 1900s.

LOST YORK IN COLOUR 87

York Minster and
St William's College in
the 1970s.

YORK

York Minster in the 1980s to show the green open spaces of the city.

LOST YORK IN COLOUR 89

York Minster pictured in around the mid-1960s with wonderful old cars of the period.

7

MODERN YORK EMERGES DURING THE TWENTIETH CENTURY – A CITY OF PARKS, GARDENS, GALLERIES, MUSEUMS & SPLENDID HOUSES

The four chief gateways and the one or two posterns and towers have each a particular fascination, and when we begin to taste the joys of York, we cannot decide whether the Minster, the gateways, the narrow streets full of overhanging houses, or the churches, all of which we know from prints and pictures, call us most. In our uncertainty we reach a wide arch across the roadway, and on the inner side find a flight of stone steps leading to the top of the wall. We climb them, and find spread out before us our first notable view of the city. The battlemented stone parapet of the wall stops at a tower standing on the bank of the river, and on the further side rises another, while above the old houses, closely packed together beyond Lendal Bridge, appear the stately towers of the Minster.

Gordon Home,
Yorkshire, 1908

As industry grew in the 1800s, the expanding dirty city, like many of Victorian England, generated wealth on the one hand, but filth and squalor on the other. However, industrialists such as Joseph Rowntree understood the benefits of open spaces and exercise. They provided York's extensive parks and gardens, many of which we enjoy today.

From the city walls, the visitor can gain a remarkable view of the still impressive gardens of the splendid houses of the 1700s and 1800s.

Being an important location for industry and commerce may come at a high price during times of conflict, something experienced by York over many centuries. However, the damage during the Second World War was especially distressing when, on 29 April 1942, York suffered retaliatory bombing as part of so-called Baedeker Blitz by the German Luftwaffe. Ninety-two people were killed and hundreds were injured, with some famous and historic buildings damaged and gutted. The Baedeker Raids occurred from April to June 1942 as retaliation for the Bomber Command attack on the historic German city of Lübeck. More than 1,000 people died and the ancient 'Old Town' of timber buildings was virtually destroyed by incendiaries. Hitler's retaliatory raids were named after the Baedeker travel guidebooks with old, historic, English cities identified as targets because they were three-starred in the guides.

Once again York recovered from times of conflict and disaster, and this has been so throughout York's long history. In the twentieth century post-war period, York emerged as a popular visitor destination with a growing tourism industry. In the 1960s, the city gained a major 'new' university, the University of York, and the region has continued to grow in status and prosperity. Modern York has grown to be a post-industrial success story and regional centre for work, play, health care, festivals, events, sports and pastimes. Today, two main drivers of the city's economy are education and tourism. In 1963, the University of York admitted its first students when it was opened on sites at Heslington and the King's Manor, and the college by the city walls has been renamed as the University of York St John.

Walmgate leads straight to the bridge over the Foss, and just beyond we come to fine old Merchants' Hall, established in 1373 by John de Rowcliffe. The panelled rooms and the chapel, built early in the fifteenth century, and many interesting details, are beautiful survivals of the days when the trade guilds of the city flourished. On the left, a few yards further on, at the corner of the Pavement, is the interesting little church of All Saints, whose octagonal lantern was illuminated at night as a guiding light to travellers on their way to York. The north door has a sanctuary knocker.

Gordon Home,
Yorkshire, 1908

Dominated by its spectacular minster, York has a wealth of open spaces, from Victorian parks to luxurious private gardens, and from libraries, museums to art galleries and theatres. Many parts of York have wide, tree-lined avenues and attractive Georgian and Victorian terraces and villas. With abundant museums, galleries and parks, York provides an excellent quality of life for its residents. A walk around the city walls reveals a wealth of urban greenspace with grass and trees below the stone battlements, but also an amazing richness of splendid urban gardens of houses great and small. The Yorkshire Museum, for example, is situated in a mature park, York Museum Gardens, with trees, flowerbeds and abundant historic features including the ruins of St Mary's Abbey, which before the dissolution was one of the wealthiest abbeys in northern England, and the remains of a Roman fortress wall.

In 1975, the National Railway Museum opened, near the centre of York and together with the Castle Museum, Clifford's Tower, and the walls, helped to confirm the attractiveness to visitors of the city. The opening

of the Jorvik Viking Centre and Museum developed this theme further, and York tourism has continued to grow and to thrive. Furthermore, a walk around the walls provides the tourist with a wonderful experience and, above all, a panoramic view of the modern city.

> The beautiful fragments of St. Mary's Abbey are close to the river, and the site is now included in the museum grounds. In the museum building itself there is a wonderfully fine collection of Roman coffins, dug up when the new railway-station was being built.
>
> Gordon Home,
> Yorkshire, 1908

During the 1950s and 1960s Cold War, the headquarters of the No. 20 Group, Royal Observer Corps was moved to the newly constructed York Cold War Bunker in the Holgate area of York. It was opened on 16 December 1961, and was in operation until 1991, when it was converted into a museum owned and managed by English Heritage.

In 1971, York became an army Saluting Station, which fires gun salutes five times a year to mark important commemorations such as the Queen's Birthday. The date marked 1,900 years of a military presence in York, a long history going back to the Romans.

> We can see the restored front of the Guildhall overlooking the river from Lendal Bridge, which adjoins the gates of the Abbey grounds, but to reach the entrance we must go along the street called Lendal and turn into a narrow passage. The hall was put up in 1446, and is therefore in the Perpendicular style. A row of tall oak pillars on each side support the roof and form two aisles. The windows are filled with excellent modern stained glass representing several incidents in the history of the city, from the election of Constantine to be Roman Emperor, which took place at York in A.D. 306, down to the great dinner to the Prince Consort, held in the hall in 1850.
>
> Gordon Home,
> Yorkshire, 1908

Aerial view of York Minster in the 1970s by W. J. Green.

LOST YORK IN COLOUR 93

Following the great fire of 9 July 1984, the Minster was pictured by Derek Philips to show the roofless South Transept just two days later.

Micklegate Bar, early 1900s.

Above: Micklegate, early 1900s.

Left: Monk Bar in the 1930s.

Above: St Sampson's Square and market stalls around 1906.

Right: Petergate in the mid-twentieth century.

96 LOST YORK IN COLOUR

Above: The Minster from the outer walls, late 1800s.

Left: The Shambles around 1933 and emphasising the dark, narrow character of the old street.

LOST YORK IN COLOUR 97

Above: The Shambles in the 1930s.

Right: The Shambles in the 1940s.

Above: View of York Minster in the 1970s.

Left: The paved and cobbled York Shambles, early 1900s.

York Minster in around 1905.
Inset: York from the city walls in the 1940s.

100　LOST YORK IN COLOUR

9.—YORK MINSTER.

Above: York Minster in the 1920s.

Left: York Minster from an engraving in the 1800s.

LOST YORK IN COLOUR 101

Above: York Minster shown in the 1970s from Bootham Bar.

Right: York Minster in the 1940s.

8
TRANSPORT IN, AROUND & THROUGH YORK

Located in a floodland with peat bogs and marshes around it, and at the confluence of two major rivers, York has always been vulnerable to inundation. Therefore, it was hardly a surprise when floods occurred in 1998, and then even worse in 2000. In October and November 2000, the River Ouse rose dramatically and York suffered a period of very severe flooding with around 300 houses flooded. Fortunately, serious casualties were avoided but then York folk are used to living with their river and visitors can sometimes expect the roads to be under water.

There could scarcely be a better approach to such a city than that furnished by the railway-station. Immediately outside the building, we are confronted with a sloping grassy bank, crowned with a battlemented wall, and we discover that only through its bars and posterns can we enter the city, and feast our eyes on the relics of the Middle Ages within. It is no dummy wall put up to please visitors, for right down to the siege of 1644, when the Parliamentary army battered Walmgate Bar with their artillery, it has withstood many assaults and investments. Repairs and restorations have been carried out at various times during the last century, and additional arches have been inserted by the bars and where openings have been made necessary, luckily without robbing the walls of their picturesqueness or interest. The bright, creamy colour of the stonework is a pleasant reminder of the purity of York's atmosphere, for should the smoke of the city ever increase to the extent of even the smaller manufacturing towns, the beauty and glamour of every view would gradually disappear.

Gordon Home,
Yorkshire, 1908

As York grew and transportation developed, the road networks reached ever outwards from the old town to the peripheral villages, hamlets and townships. Over the centuries, horse-drawn carriage, horse and cart, and walking gave way to trams, buses, and then the motorcar. However, for transportation for industry and commerce, along with roads there were canals and rail, and of course the river. Today, York links to the A1 (M) and the M1 via the A64.

The developing roads extended across the flatlands to unite formerly separate communities, but until the toll-charging turnpikes, many roads were almost impassable with surfaces poor, muddy and rutted, and maintenance minimal. However, by the 1700s and 1800s, toll-charging turnpikes were de rigueur and new, often straight roads cut directly through the newly enclosed countryside; a new order was imposed. Then, with innovation in road surfacing, which moved away from stones collected by the rural poor, to limestone chippings for Macadam surfaces, Tarmacadam soon followed and the modern roadway was born.

However, at the core of York transportation was the great River Ouse, an artery for the city and its people. By the 1800s, the railways became a new hub which placed York at the centre of regional and national transportation networks and it remains so today.

The bridges over the rivers were always important in terms of travel and trade, but also in times of conflicts. Control of passage gave power over the city and the countryside around.

Above right: Bootham Bar and the Minster early 1900s.

Below right: Bridge over the River Ouse, 1920s.

104 LOST YORK IN COLOUR

Lendal Bridge in the 1940s with cyclists, old buses and a white van.

Old bridge over the River Foss with a hay-cart crossing, early 1800s.

Above: River Derwent around 1906 showing the beautiful rural setting of the old city.

Left: Pleasure cruiser the *Duchess of York*, based at Hills Boatyard Lendal Bridge, pictured in the 1970s.

LOST YORK IN COLOUR 107

Skeldergate Bridge in the early 1900s, with a river cruise.

108 LOST YORK IN COLOUR

THE FOUR BARS OF YORK

Monk Bar

Walmgate Bar

Bootham Bar

ET. 5834

Micklegate Bar

The four York bars in the 1970s.

The old Ouse Bridge in the 1500s.

The River Ouse from Lendal Bridge in the early 1900s.

Up river from Ouse Bridge, early 1900s.

Walmgate Bar in the 1840s with cart, ladies, a gentleman and a wheel-barrow.

LOST YORK IN COLOUR 113

Walmgate Bar in the 1930s.

Walmgate Bar in the early 1900s showing the massive structure still intact.

York from the city walls, early 1900s.

116 LOST YORK IN COLOUR

York, from River Ouse.

A tranquil view of York from the River Ouse, around 1900.

9
SPORTS, THEATRE, CULTURAL ACTIVITIES & TOURISM

With York City FC, the area has a modest professional football club, though one that has had hard times in recent decades. It has even toyed with Rugby League and other sports. However, York's sporting claim to fame is in horse racing with the York Races being one of the most famous racing centres in Britain. The third-biggest racecourse in Britain in terms of total prize money, York attracts around 350,000 race-goers annually to the Knavesmire course. The name is from Anglo-Saxon 'knave', a man of low standing, and 'mire', swampy pasture for cattle. It is suggested that various forms of horse racing here go back to Roman times. This is also the location where Dick Turpin was hanged.

York does have rich traditions in music, theatre and other popular entertainments. With a thriving tourism industry and a major university, at night, the city is alive with theatre and music lovers, pubs, restaurants and more. The city also hosts festivals, fairs and concerts throughout the year.

Visitors have long been drawn here as a place of learning, as a regional centre and a place to do business, and now, increasingly, as a place for tourism. The Jorvik Viking Centre, for example, opened in 1984 and has received over twenty million visitors. Provision for the latter in particular has meant a wealth and diversity of eating places and also of entertainments such as the theatre and for the arts. York also hosts festivals and activities designed to draw in and to entertain both locals and visitors alike. Central to York's attractiveness to tourists are its wide variety of museums and related attractions including:

- The Castle Museum
- The Yorkshire Museum
- The Jorvik Viking Centre
- The Roman Baths
- The Mansion House & Lord Mayor's Lodgings
- The Treasurer's House
- The York Dungeon
- The National Railway Museum
- York Art Gallery

- The Richard III Experience at Monk Bar
- The Bar Convent Museum
- York Model Railway Museum
- York Minster
- Fairfax House
- Clifford's Tower
- The Guildhall
- The Merchant Adventurers' Hall
- The Bar Walls

We finally come back to the Minster, and entering by the south transept door, realize at once in the dim immensity of the interior that we have reached the crowning splendour of York. The great organ is filling the lofty spaces with solemn music, carrying the mind far beyond petty things.

Gordon Home, Yorkshire, 1908

American advertisement for Railway Tours on the Cathedral Line through England in 1925.

Typical of Old England
On the London and North Eastern Railway

A magic thread through Britain

It winds out of London town — this magic "thread" — along a pleasant English countryside teeming with literary and historic traditions; through the wooded hills and green meadows of Middlesex and Hertfordshire; past the land of the Pilgrims, where the American nation was conceived; skirting the enchanted River Ouse; to the famous Norfolk Broads, the Yorkshire Moors and Dales, the Northumberland Fells; into the wild beauty of the Scottish Highlands.

It's the route of the London & North Eastern Railway — "The Cathedral Line" — track of the "Flying Scotsman", shortest and swiftest to Scotland.

If you're going abroad, plan your British tour to follow the magic "thread" — and plan now. Save time and money, and still see everything that matters. Concentrate on the Eastern Counties — the historic side of Britain.

The London & North Eastern Railway's Royal Mail Routes, via Harwich, form the ideal link between England and Continental Europe.

For illustrated booklets and details of special tours for American visitors, communicate with

H. J. KETCHAM, GENERAL AGENT
London & North Eastern Railway
311 Fifth Avenue, New York

LONDON AND NORTH EASTERN RAILWAY

OF ENGLAND AND SCOTLAND

LOST YORK IN COLOUR 119

RAIL MUSEUM
and Historic York

Guidebook to the Railway Museum from the 1970s, one of the national museums which placed York firmly on the tourism and heritage map.

CASTLE MUSEUM YORK

HANDBOOK 2/6 (12½ n.p.)

Above: Street scene from the Castle Museum, Half Moon Court, on a 1960s' postcard and a unique attraction of the time.

Left: The Castle Museum guidebook from the 1960s.

Above: The ruins of St Mary's Abbey, early 1900s.

Right: The modern Shambles in around 1971.

Visit to York of the Prince and Princess of Wales to review the North of England Volunteers at York Racecourse in August 1866.

Walking the walls of a clean and green York, in around 1973.

TEAM LINE UP

YORK CITY	v	GRIMSBY TOWN
Red/Navy Blue		White/Black
GRAHAM BROWN	1	NIGEL BATCH
PETER SCOTT	2	SHAUN MAWER
ROY KAY	3	DAVE BOOTH
PETER STRONACH	4	JOE WATERS
STEVE FAULKNER	5	GEOFF BARKER
ANDY CLEMENTS	6	KEVIN MOORE
NEIL WARNOCK	7	TONY FORD
TONY YOUNG	8	TERRY DONOVAN
DAVID LOGGIE	9	MIKE LESTER
IAN McDONALD	10	BOBBY MITCHELL
GORDON STANIFORTH	11	BOBBY CUMMINGS
	12	

Referee: **ALAN PORTER** (Bolton)
Linesmen — Yellow Flag: **R. PALLISTER** (Middlesbrough)
Red Flag: **J. M. THOMPSON** (Newcastle upon Tyne)

To-nights Matchball Sponsor:
LEEDHAMS (York) Limited
Rougier Street, York.

Fixture Lists: Attractive well designed fixture list cards listing all York City Football Club Fixtures for the 1978/9 season are now available from the Travel Club Office. Price 95p.

YORK CITY F.C. LOTTERY

OVER £3,000 IN PRIZES TO BE WON EVERY WEEK

1st £1,000
2nd £500
3rd £250

plus hundreds of other prizes

Lottery drawn every Saturday

Promoter: Maureen Leslie, York City F.C.,
Bootham Crescent, York.

Next Match at Bootham Crescent:
Tuesday next, 22nd August — **York City v. Portsmouth**
Football League Division Four, Kick Off 7.30 p.m.

YORK CITY FC

WELCOME
GRIMSBY TOWN

Football League Cup First Round 2nd leg
Season 1978/79
Tuesday, August 15th 1978
Kick Off 7-30 p.m.
Match No. 1

Directors
M. D. B. Sinclair *Chairman*, R. B. Strachan MA, LLB, FCIS
F. H. Magson
Secretary: G. Teasdale, FAAI Manager: C. Wright

Additional copies of this programme are available from the Travel Club office, price 10p. each

Founded 1922
York City Association Football & Athletic Club Limited
Bootham Crescent, York YO3 7AQ

York City versus Grimsby 1978 League Cup team line-up including Neil Warnock before he was famous.

Above: York Historical Pageant, 1909.

Right: York guidebook from the 1970s with text by R. W. Horton.

York Minster from River

Above: York Minster shown in the 1970s.

Left: York Minster from the river and a river cruise with the *River King*, probably 1920s.

BIBLIOGRAPHY & SUGGESTED READING

There is a plethora of literature on the history of York, of its people, its heritage, and its industries. The following are just a few that helped in the preparation and research for this book:

Anon. (undated) *Rail Museum and Historic York*, Yorkshire Evening Press, York.

Anon. (undated) *The Castle Museum York*, The Castle Museum York, York.

Anon. (undated) *The Land We Live In. A Pictorial and Literary Sketch-book of the British Empire Volume IV*, Charles Knight, London.

Anon. (undated) *Our Own Country. Descriptive, Historical, Pictorial*, Cassell, Petter, Galpin & Co., London.

Finnegan, F (1979) *Poverty and prostitution: A Study of Victorian prostitutes in York*, Cambridge University Press, London.

Gee, E. (1983) *Bishopsthorpe Palace. Residence of the Archbishops of York*, The Ebor Press, York.

Home, G. (1908) *Yorkshire Painted and Described*, A. & C. Black Ltd, London.

Home, G. (1922) *York A Sketch-Book*, A. & C. Black Ltd, London.

Home, G. (1936) *York Minster and Neighbouring Abbeys & Churches*, J.M. Dent & Sons Ltd, London.

Horton, R.W. (undated) *The City of York*, Pitkin Pictorials Ltd., London.

Knight, C. (ed.) (undated) *Old England: A Pictorial Museum of Regal, Ecclesiastical, Municipal, Baronial and Popular Antiquities. In Two Volumes*. James Sangster and Co, London.

Rotherham, I.D. (2009) *Peat and Peat Cutting*, Shire Publications, Oxford.

Rotherham, I.D. (2010) *Yorkshire's Forgotten Fenlands*, Pen & Sword Books Limited, Barnsley.

Rowntree, B.S. (1901) *Poverty: A Study of Town Life*.

Vesey-Fitzgerald, B. (undated) *The British Countryside in Pictures*, Odhams Press Limited, London.

Wilson, B. & Mee, F. (2009) *St Mary's Abbey and the King's Manor, York. The Pictorial Evidence*. The Archaeology of York Supplementary Series, Volume 1, York Archaeological Trust, York.

ABOUT THE AUTHOR

Ian Rotherham first discovered the joys of York and its museums on a trip by steam-train from Sheffield in the 1960s. The street scenes reconstructed in the Castle Museum, and a walk on the walls made a lasting impression, and he fell in love with the ancient city. He is Professor of Environmental Geography and Reader in Tourism and Environmental Change at Sheffield Hallam University. An ecologist and environmental historian, he is a worldwide authority on landscape history and urban environments. He has been researching and writing about York and Yorkshire for many years and has campaigned for its conservation, improvement, and its wider promotion. He has published over 400 papers, articles, books and book chapters, has a popular BBC Radio Sheffield 'phone-in, and writes for local and regional newspapers, particularly the *Sheffield Star*, The *Sheffield Telegraph*, and the *Yorkshire Post*. He has written a book on *Yorkshire's Forgotten Fenlands*, and two recent books for Amberley Publishing on the Yorkshire coast – *The Dinosaur Coast* and the *Viking Coast*. Ian also wrote *Lost Sheffield in Colour*, and *Lost Nottingham in Colour*, both for Amberley Publishing in the same series as the current volume.

He lectures widely to local groups and works closely with the bodies such as the Wildlife Trusts, Natural England, Historic England the National Trust and the RSPB. Ian is a Regional Tourism Ambassador for Sheffield and South Yorkshire, and has worked on major tourism and conservation projects across the county. He is a Fellow of the PLACE (People, Landscape and the Cultural Environment) research centre based at York.

An illustrated history of naval victualling in Plymouth

City of Plymouth
MUSEUMS & ART GALLERY
DRAKE CIRCUS PLYMOUTH PL4 8AJ
tel 01752 264878 fax 264959
http://www.plymouth.gov.uk/

This book is a joint publication between Plymouth City Museum & Art Gallery and Plymouth Development Corporation. All images are copyright of Plymouth City Museums & Art Gallery, excepting those reproduced by kind permission of Plymouth Naval Base Museum and Plymouth Development Corporation. Written by Dr Michael Nix; design Jim Gallacher; photography Trevor Burrows and Robert Chapman; printed by Delton Communications. © Plymouth City Museum & Art Gallery.
ISBN 0 904788 14 8

HMS *Britannia*, entering Devonport Harbour, by L Haghe, c1828.

THE ROYAL WILLIAM VICTUALLING YARD

[**victualling** *(vit' ling)* supplying with provisions; —taking in provisions; —obtaining food for ships. — **victualler** *(vit' ler)* one who supplies provisions; —ship for carrying provisions to other ships.]

Victualling in Plymouth

In the seventeenth century, the first Secretary to the Admiralty, Samuel Pepys, remarked that the English sailor loves his *"bellie above everything else"*. For the navy, success in war and peace depended to a high degree on the adequate supply of food and drink.

Since at least the thirteenth century, Plymouth has been involved in victualling and supplying fleets and troops. For hundreds of years campaigning armies, victorious in battles such as Poitiers in 1356, and disastrously defeated in fighting on the Isle of Rhe in the 1620s, were supplied from Sutton Harbour. Plymouth similarly victualled the fleet of sixty fighting ships sent to oppose the Spanish Armada in 1588.

The port's role as a naval victualling station grew substantially from the middle of the seventeenth century. In the 1650s, during the Commonwealth period which followed the Civil War, new victualling storehouses were erected at Lambhay in Sutton Harbour. These buildings supplemented those already existing at Coxside.

Towards the end of the century British naval operations increasingly focused on the western approaches and the threat posed to international trade by the French Atlantic bases. A major new dockyard at Plymouth was constructed in the 1690s as a counter to this challenge.

With the concentration of Britain's main battlefleet in the western approaches, the Royal Plymouth Victualling Yard and Office in Sutton Harbour expanded considerably. The method of blockading the French first-class naval bases at Brest and Rochefort adopted in the eighteenth century required that ships remained at sea for months at a time. The task of supplying 20,000 men or more with meat, bread, beer, vegetables and biscuit, for such long periods was immense.

Medieval ship from the seal of the town of Sutton.

The Spanish Armada off Plymouth with the English fleet having manœuvred behind them. One of a series of charts by Robert Adams showing the progress of the fleets up the Channel, 1590.

Crediton, Devonshire, by F R Lee, 1843. A typical landscape of the region from which food was supplied to the navy.

Carved wooden lintel from the entranceway to the Victualling Office, Lambhay.

Drawing of the old Victualling Yard, Lambhay, by Sibyl Jerram, 1913.

Early Autumn, South Devon, by W Eggington, 1843.

The system of provisioning warships at sea from Plymouth proved, at times, remarkably effective. This is evidenced from various admirals who recorded low sickness rates among their men. Just before the battle of Quiberon Bay in November 1759, for example, Admiral Hawke, after six months of almost continuous sea service, could report 20 sick out of 14,000 men.

The navy's policy of supplementing dry-stores with fresh provisions meant that the contribution of Devon's agriculture became increasingly important. However, the burden of supply sometimes fell heavily on the region's population. In 1795, following a bad harvest, the provisioning of a fleet which remained off the coast for two months, placed enormous demands on a very limited food surplus. High prices in local markets led to serious rioting.

The victualling yard and office at Lambhay also played a significant role in naval expeditions whose primary purpose was exploration and discovery. In 1768, before his first great voyage to the Pacific, Captain James Cook stowed on board HMS *Endeavour* provisions calculated to last eighteen months. These included four tons of beer, 185 pounds of great Devonshire cheeses, salt beef by the ton and 604 gallons of rum. However, by the beginning of the nineteenth century, the numerous storehouses, lofts, cellars, bakery and granary at Lambhay were proving to be insufficient and inefficient.

Dockyard and Harbour, Devonport, by T Allom, 1829-32.

Chart of Plymouth Sound, Hamoaze and Cattewater, surveyed in 1797.

'Nautical Intelligence' from "The Star", September 1803.

PLYMOUTH, AUG. 30.—Sailed, with live cattle and fresh vegetables for the squadron off Brest and off the Black Rocks, the ARDENT, of 64 guns, Capt. WINTHORP. By the latest accounts by letters from off Brest, it appears that the French squadron in the outer Road still continue there, and in sight of the British in shore squadron manœuvre their ships daily in furling, unfurling, and handing sails, exercising great guns and small arms, and manœuving occasionally with their bompards, or large gun-vessels.— Went down the harbour, being completely fitted for sea, la TROMPEUSE, of 16 guns, Capt. GOODWIN: she came to in the Sound to wait for orders. All the small vessels, particularly the gun brigs and those with sliding keels, are ordered to be got ready as fast as possible, as they are from their easy draught of water fit for the defence of a line of coast, the entrance of rivers, &c. &c.

Came in the Ardent, a transport, with seamen and landmen for the fleet, from the Irish Channel. Vice Admiral Sir CHARLES POLE, Bart. President of the Board of Naval Commissioners instituted by Act of Parliament, to inquire into all the naval abuses whatsoever, and the rest of the Board, are arrived at Dock; they proceed directly to examine the Dock Yard, Victualling Office, South Down Brewery, and the Royal Naval Hospital, to make such necessary inquiries, and reform such abuses as may appear to them fit and necessary, and for the good of his Majesty's service.

Officers on board HMS *Hero*, 1860. The ship was victualled at the Royal William Yard prior to her departure to Canada, with the Prince of Wales on board.

The New Victualling Office Works from offshore, by Henry B Carter, 1828.

In 1824, the Commissioners of Victualling appointed the architect and engineer, Sir John Rennie, to design and build a new victualling yard at Cremyll Point, East Stonehouse.

With some justifiable pride, Rennie later wrote:

At Cremill Point a fine establishment was formed in 1834 for victualling the Navy and for this purpose no place could have been better selected. Its proximity to the Dockyard, the Hamoaze and the Sound, and the great depth of water rendering it accessible at all times of the tide, enabled it to supply provisions to the different vessels of war with the greatest despatch, facility and economy, whilst its excellent internal arrangements are so designed that every article of provisions can be manufactured and supplied with equal readiness and cheapness.

Work on the new yard commenced in 1825 and the arduous task of levelling the site was undertaken by convicts. The first building Rennie constructed was the Clarence Block which was designed as a general store. This was followed in 1827 by the Melville Block, which functioned as a store and administrative centre. Other buildings included in the overall 16-acre layout

The Royal William Victualling Yard, Stonehouse, by Nicholas Condy, 1840.

incorporated a mill, bakery, brewery, slaughterhouse, cooperage and officers' residences. The large basin could accommodate up to six transports or merchant vessels.

Although the transfer of offices and stores from Lambhay to the Royal William Victualling Yard occurred in July 1831, building work was not completed until the mid-1830s. The Yard proved its use throughout the nineteenth century, particularly in periods of crisis such as the Crimean War and the later military expedition to the Sudan.

The function of the Yard at Plymouth changed as the century progressed. The introduction of canned food and the distribution of naval uniforms and mess utensils helped undermine the Yard's original manufacturing base. The buildings were increasingly used as storehouses. This was followed by the Naval Ordnance Department taking control of the Brewhouse and Clarence Blocks in 1891.

Transport, munitions and stores at the Yard, c.1950, reproduced courtesy of Plymouth Naval Base Museum.

The Yard actively continued its work throughout the First and Second World Wars, increasing its staff to assist with the extra workloads. It survived the blitz in 1941 unscathed, even though Plymouth endured the heaviest air attacks on Britain during the war. In 1972 the Royal Marines' Number Two Raiding Squadron occupied the Brewhouse. Later, in the early 1980s, while millions of pounds worth of clothing was stored at one end of the yard, torpedoes were being maintained and repaired at the other.

The Royal Navy finally withdrew from the Royal William Victualling Yard in 1992. In the following year, the government set up the Plymouth Development Corporation, one of twelve Urban Development Corporations across the country. It was charged with responsibility for promoting the regeneration of three waterfront sites including the Royal William Victualling Yard. The work which the PDC has begun will open up the Yard for a mixture of uses including leisure and tourism, shopping and residential accommodation.

for executing the Office of Lord High Admiral of Great
Barracks at **Stonehouse**, near PLYMOUTH-DOCK
heir LORDSHIPS, *most obedient Servant* W.m Hay)
as the Act directs, March 16. 1786. *by William Hay, Plymouth.*

A WEST SOUTH-WEST VIEW of the ROYAL HOSPITAL near PLYMOUTH.

The Stonehouse Peninsula

Stonehouse developed considerably as a town and military centre in the latter half of the eighteenth century. A fashionable assembly room with baths, known as the Long Room, was commenced in 1756 and later incorporated into the Royal Marine Barracks, built in 1779.

The Barracks were later integrated into the layout of Durnford Street, its three-storeyed terraced houses proving popular with naval officers. Other major developments, both on Stonehouse Creek, encompassed the Royal Naval Hospital, the most advanced in Europe, and the Military Hospital.

Transport links included a cable ferry between Plymouth and Devonport which was replaced, in the early-1770s, by the single-span Stonehouse Bridge, and the Cremyll ferry to Mount Edgcumbe. Foulston's Union Street, laid out between 1812 and 1820, but heavily bombed in the last war, added to the elegance of the area.

Plymouth's early defences included an artillery tower at Firestone Bay and the Stonehouse town wall, both built in the late fifteenth or early sixteenth centuries. They also served to protect the quay facilities edging Stonehouse Creek to the north.

The Royal Naval Hospital, by J Jehner, 1782.

Detail from a map showing Stonehouse during the siege of Plymouth, 1643.

James Northcote delin.t

A View of the LONG ROOM and BAT~

1. The Long Room	4. Seats	7. Plymouth Sound	10. Mill Bay
2. The Baths	5. Bowling Green	8. Shag Stone	11. The Entrance of Ham
3. Convenient Houses	6. St Nicholas Island	9. Mew Stone	12. Mount Stone

with the Country adjacent, near PLYMOUTH.

Reading Point
Road to Crimhill passage
Barn Pool
16. Coach road thro Stonehouse.
17. The Boats of the Fleet, in the Order in which they received
her Royal Highness the Princess Amelia, at her Embarkation for Mount Edgecumbe, 23 July 1767.
18. Crimhill Passage
19. Mount Edgecumbe
20. Maker Tower

J. Mason sculp.

[Stonehouse] Pool, as it is called, ... is of sufficient depth to admit vessels of heavy burthen, and is much resorted to, especially by ships in the timber trade. There are many extensive stores in its margin, and several boat and shipbuilding yards. Considerable water frontage in Stonehouse is occupied by docks and works of the Plymouth Great Western Dock Company. Extensive fortifications are now completed, which command the entrance to the Hamoaze.

The Post Office Directory of Devonshire and Cornwall, 1873.

Previous page: A view of the Long Room and Baths, by James Northcote, 1769.

The Victualling Office, Stonehouse, by W Spreat, c.1850.

Marine Barracks at Stonehouse, Devonshire, by J Roffe, 1798.

Overleaf: An aerial view of Stonehouse and Millbay drawn from a balloon, by Henry William Brewer, 1891.

From a small thoroughfare village, this place, by the erection of the royal naval hospital, and the royal marine barracks, has risen within a few years, to a handsome and exceedingly populace town; and additional consequence is being attached to it from a new government victualling establishment, now erecting at Devil's Point, where is a magnificent supply of water . . . Besides its maritime connexion, and the business aided by the several government establishments, it has a trade in coal and timber; and in the neighbourhood are large and valuable limestone quarries.

Pigot and Co's Directory of Devonshire, 1830-31.

The Royal William Victualling Yard,
by William Williams, 1835.

A New Victualling Yard

In 1821 the Victualling Board, recognising the inadequacy of Plymouth's victualling operations in and around Sutton Harbour and Millbrook Creek, determined to centralise. Two years later, the site for a new yard at Stonehouse was approved.

In June 1824 an act of Parliament sanctioned the purchase of land and detailed arrangements for the supply of water. Authorization was also given for moving the *"Landing Place of the Ancient Ferry of Cremyll"* into Stonehouse Pool, for creating a *"Hard or Landing Place, in every respect fit and proper for embarking and disembarking His Majesty's Subjects"*, and for building a road to the new ferry.

Although the southern part of the promontory was left undisturbed to provide shelter, work was commenced on levelling an eight-acre area in 1825. Convict labour was employed and it proved to be a strenuous three-year undertaking. This engineering activity produced about 370,000 tons of rubble, used in reclaiming six acres from the sea, and building stone.

First page from the Act of Parliament of 1824 which led to the establishment of the Yard.

The New Victualling Office, from the parapet of the Great Wall, by Henry B Carter, 1828.

Access by Sea

Although the Royal William Victualling Yard is approached by visitors from landwards, the Yard is oriented seawards. To avoid the problems of limited tidal access at the old yard at Lambhay, a basin was included as part of the north wharf. It could accommodate, according to Rennie, *"about six transports or merchant vessels of a large class"*. A swivel bridge, made by the Horseley Iron Company, was added as an afterthought and installed to improve circulation around the yard.

Further access to the Yard was provided by the Clarence Steps. Surmounted by a pair of cast iron gates embellished with crossed fouled anchors, they provided a seaward, ceremonial entrance for visiting VIPs.

A tunnel leading from Firestone Bay gave an additional approach into the Yard. Its purpose was to provide occasional use for transferring light goods between ship and shore when the ebb tides were too strong for making a passage around the Cremyll Point.

The New Victualling Office, Devil's Point, by W le Petit, 1849. The engraving shows the Clarence Block and Steps.

THE NEW VICTUALLING OFFICE, DEVIL'S POINT, PLYMOUTH.

Access by Land

To enhance security, the Royal William Victualling Yard was surrounded by a high wall, with the main landward entrance through a gateway from Cremyll Street. The gateway is monumental in scale and surmounted by a 13 foot tall statue of William IV, after whom the Yard was named.

To the right of the gateway is the doorway into the slaughterhouse. The previous victualling abattoir was located on Cremyll Point, somewhere near the Brewhouse. Rennie's design was for fresh meat only and up to 100 animals could be slaughtered per day. Salted meat was imported from Deptford and stored.

To the left of the gateway is the police house. The police establishment consisted of an inspector, three sergeants and twelve constables. They were employed to prevent pilfering and to check on visitors to the Yard. It was a popular tourist attraction in the nineteenth century and guided tours were arranged.

Just inside the gateway, Rennie gave special architectural treatment to the slaughterhouse and police house walls fronting the entrance. By using colonnading, he provided the area with a sense of grandeur, unity and dignity.

MELVILLE

Clarence and Melville

John Rennie was instructed to design a yard which would be *"capable of embracing every requisite purpose"*. He planned a self-contained food and drink manufacturing complex with sufficient storage for the varied necessities of a fleet.

Although the sea wall was started in 1826, the first building on the site, the Clarence store, was not authorised by the Victualling Board until the following year. It was named after the Duke of Clarence, later King William IV. The design of the store set the pattern for general masonry specifications and future building features.

Work commenced next on the Melville Square building which incorporated a vast storage space and administrative offices. Situated at the head of the basin, the three-storey structure was arranged around a central square. It was adorned with an elegant clock and bell tower. The clock, made from 1,393 parts, was purchased from Vulliamy of Pall Mall, London.

The Brewhouse and the Bakery

The old bakery at Lambhay in Sutton Harbour was capable of producing 50 tons of bread a week, but efficient production was difficult with the flour-mills and granary quarter of a mile away. Rennie's remedy to this problem was to incorporate all three functions into one building. By 1843, manufacturing had commenced, using two steam engines and 27 millstones. The mills and bakery were capable of processing 122,500 kilos (270,000 lbs) of flour per week.

The old victualling brewhouse was built in 1733 at Southdown, on the Cornish side of the Hamoaze. It could only be reached at high tide. Rennie's replacement was the massive Brewhouse which was capable of producing 137,000 litres (30,000 gallons) of beer a day. Unfortunately, the naval beer ration was discontinued in 1831 and only small quantities were produced for the Royal Naval Hospital and the Royal Marine Infirmary.

Rennie's design for the two buildings included specifications for machinery and equipment used in the making of beer and bread. Another feature were central bays which projected from both buildings to accommodate transhipment of supplies and goods by wall cranes to and from moored vessels.

The Victualling Office from Cremyll Passage, by R Martin, c.1835. The Bakery chimney is on the left and the Brewhouse on the right.

The Old and New Cooperages

The Napoleonic Wars placed enormous demands on the supply of barrels for the storage of food and drink on board ship. Rennie, aware of the need for rapid expansion in production in time of conflict, took this into account when designing the first cooperage.

The cooperage consisted of an inner, fire-proofed building, where the barrels were made, and outer ranges for ancillary activities and storage. To become a cooper required a five year apprenticeship and was an extremely skilled job. A maximum of 80 coopers could be employed at the Yard.

Following the Comptroller of Victualling's decision to concentrate the manufacture of large barrels at Deptford in 1869, and the use of the old cooperage by the Naval Ordnance Department in 1891, a smaller cooperage was constructed. It was completed in 1899.

Top: Working in the New Cooperage, c.1950. Reproduced courtesy of Plymouth Naval Base Museum.

The Officers' Houses

The Yard's officers were accommodated in two houses on the east side of the site. Each residence was two rooms wide, with service rooms in the basement and a kitchen. There were also carriage houses and stabling.

At the rear of the houses were gardens with greenhouses which were supplemented by larger gardens near the Back Alley.

The Future of the Royal William Victualling Yard

On 1 April 1993 the Royal William Victualling Yard entered on a new phase of its life. The Government established the Plymouth Development Corporation to promote the regeneration of three former MoD sites on Plymouth's waterfront - including the Royal William Victualling Yard. It was given a budget of approximately £40 million for the three sites and a five year life span.

PDC's vision for the Yard is as a location which is open to the people of Plymouth as a place to visit, and in which to live, to work and to relax. With a combination of visitor attractions, cafes, restaurants, shops, new homes and office space, together with its magnificent architecture and setting, the Yard should also become a magnet for visitors from far and wide.

PDC has always recognised that the key to making this happen is to convince commercial developers that it is a practical and workable proposition. The essential precondition for this is to improve access and parking to

the Yard, which was originally designed to be served mainly by sea. This has been a slow process. Following a public inquiry decision in October 1996, the PDC was finally able to put its plans for improving roads and providing additional parking into action.

Repair and renovation of the ancient buildings and updating of services like electricity, telecommunications and drainage have also been part of the essential work of preparing the Yard for modern day use which has been undertaken by the PDC.

So, what of the future? Quite early on in PDC's life it became clear the the task of regenerating the Yard would take longer than the five year life span of the organisation. When the PDC closes on 31 March 1998, it expects to hand over responsibility for the Royal William Victualling Yard to a body set up specifically to continue, with the aid of public and private finances, with the task of bringing this beautiful heritage site back to life.

Sir John Rennie

The Royal William Yard was designed by Sir John Rennie. He was the son of John Rennie, one of the engineers entrusted with the building of the Plymouth Breakwater for the Admiralty. With the death of his father in 1821, John was contracted to continue the work. One of his tasks was to build the Breakwater lighthouse which was based on the Smeaton's Eddystone lighthouse principle of dove-tailing the foundation blocks together.

Rennie was born in London in 1794. Practical knowledge in civil engineering was acquired working with his father. He assisted with the construction of Waterloo and Southwark Bridges and undertook the building of London Bridge, which was opened in 1831. Other work included Fens drainage and the layout of a system of railways in Sweden.

Rennie's conception for the Royal William Victualling Yard incorporated the need for rapid expansion in time of war. The old victualling establishment in Sutton Harbour had been stretched to full capacity during the Napoleonic Wars. The new Yard was therefore sufficiently flexible in layout to accommodate swift transformation in wartime.

The important role of supervising the site was undertaken by Philip Richards who *"invariably discharged his duties ... with the greatest industry, zeal, skill and integrity for the Public Service"*. He was paid £400 per annum and was provided with a house.

Cherry and Pevsner, in their book 'The Buildings of England: Devon', describe the Yard as *"the first and most grandiloquent of the monumental compositions created by the Victualling Board of the Navy after the Napoleonic Wars ... [it] ... is also among the most remarkable examples of an early 19th century planned layout of industrial buildings anywhere in England"*. This is certainly a fine tribute to the work of Rennie and his colleagues.